The Impressionists

Edgar Degas

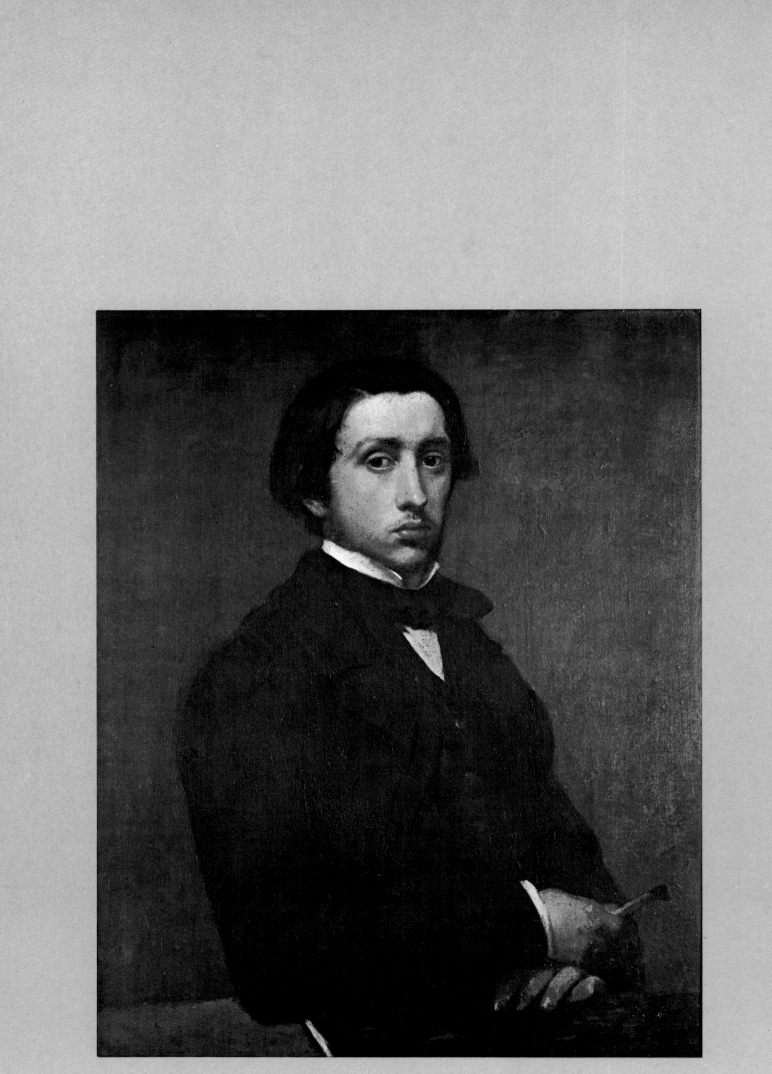

Self-Portrait, 1854–55. Canvas, 31⁷/₈ × 25¹/₄ in. Paris, Musée du Louvre. (Photo Musées Nationaux)

Edgar Degas

Antoine Terrasse

CASSELL • LONDON

Contents

Cassell Publishers Limited
Artillery House, Artillery Row
London SW1P 1RT

© Gruppo Editoriale Fabbri S.p.A., Milan 1972

This edition 1988

British Library Cataloguing in Publication Data

Terrasse, Antoine
 Degas. — (The Impressionists).
 1. Degas, Edgar, 1834-1917
 2. Painters — France — Biography
 I. Title II. Series
 759.4 ND553.D3

 ISBN 0-304-32165-6

Series edited by Daniel Wildenstein
Produced with the collaboration of the Wildenstein
Foundation, Paris

Reproduction of the works of Degas and Forain
© SPADEM, Paris

Photo credits: Wildenstein Archives, New York; Gruppo
Editoriale Fabbri, Milan; Bibliothèque Nationale, Paris;
Musées Nationaux, Paris; Josse, Paris; Giraudon, Paris;
Routhier, Paris; Durand-Ruel, Paris; Archives
Photographiques, Paris

Printed in Italy by Gruppo Editoriale Fabbri S.p.A.,
Milan

With Degas

<div align="right">by Ernest Rouart</div>

Self-Portrait.
Pencil on white paper,
$10^5/8 \times 7^1/4$ in.

If there's a man who has been the victim of utterly false and spiteful rumors, it is certainly poor Degas. What wickedness, what nastiness hasn't he been accused of?

He himself, it is only fair to say, took pleasure in keeping up and giving added weight to that legend of cruelty which enveloped him. And people who hardly knew him, or those he had for some reason even slightly ruffled, never forgave his rudeness. If he seemed surly or inhospitable to visitors who chanced to disturb him while at work, the reason was that his work was sacred to him and he meant to safeguard it at any price; the hours he could devote to his art were too precious for him to permit any intruders to waste his time. But this gruff and seemingly bearish man was capable on occasion of mellowing to the point of showing affection, as may be seen from, among other things, this short note he wrote to my father, who had called on him one afternoon in order not to disturb his usual morning work session:

"I was so sorry, my good friend, to see that you came and left again. Your letter said that you would call on me, but I never imagined it would be in the

afternoon. For you there are no 'orders of the day,' no work nor anything else I would not leave off for the pleasure of seeing you. Do you understand that, my old friend?"

For friendship was a cult with him, and he had so lofty a conception of it that he could not allow anything to pass which, to his way of thinking, might do harm to that noble sentiment.

It is here, and nowhere else, that one must look for the reason for falling out with Manet, and later with Renoir, not to mention certain other personalities who could not really be counted among his friends. His breach with Ludovic Halévy was, of course, an entirely different matter, the sad result of the Dreyfus case; and though he suffered greatly from this break, he [Degas] would never consent to modify his attitude toward his old friend.

This intransigence, for which many people reproved him, was at the same time one of the nobler and harsher sides of his headstrong character.

Ernest Rouart, *Degas*, in *Le Point*, Paris, February 1937, p. 7.

Degas, dance, drawing

by Paul Valéry

Every Friday Degas, a faithful, sparkling, insufferable guest, enlivened the dinner table at Monsieur Rouart's. He virtually brimmed over with wit, terror, and gaiety. He was penetrating, he clowned, he spewed forth banter, parables, epigrams, jokes, all the eloquent bursts of the cleverest misrepresentation, the surest taste, the narrowest and most lucid passion. He devastated literary men, the Institut, bogus hermits, established artists. He quoted Saint-Simon, Proudhon, Racine, and the odd maxims of Monsieur Ingres...

It's as if I can hear him. His adoring host listened to him with admiring indulgence, while the other guests—young people, old generals, mute ladies—all convulsively enjoyed his irony, the aesthetic opinions and outbursts of this marvelous coiner of witty sayings.

He made himself agreeable to me, as one might behave with someone who hardly exists. I was not worth expending a thunderbolt on. I saw, however, that he had no love for the young writers of that day. He particularly disliked Gide, whom he had met under that same roof. He was much more kindly disposed toward the young painters. Not that he refrained from scathing comments on their canvases and their ideas, but he administered the critic's lash with a kind of tender fervor that mixed strangely with his fierce irony. He went to their exhibitions; he was quick to note the slightest indication of talent; and if the artist were at hand, he would pay him a compliment and give some word of advice.

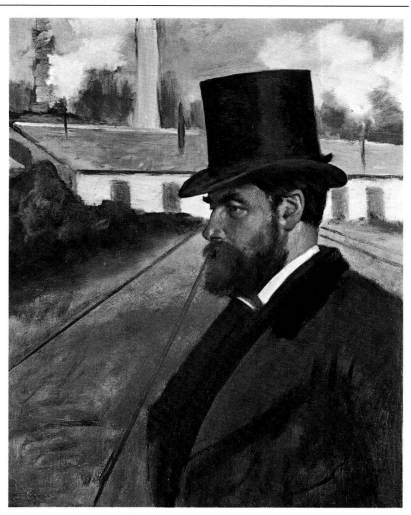

Henri Rouart in Front of His Factory, c. 1875.
Canvas, 25⁵/8 × 19³/4 in.
Pittsburgh Museum of Art, Carnegie Institute.

Paul Valéry, *Degas, danse, dessin,*
© Editions Gallimard, Paris, 1938, pp. 16-17, 19-20.

Life and works

to Nadia Boulanger — A.T.

From historical scenes
to painting everyday reality

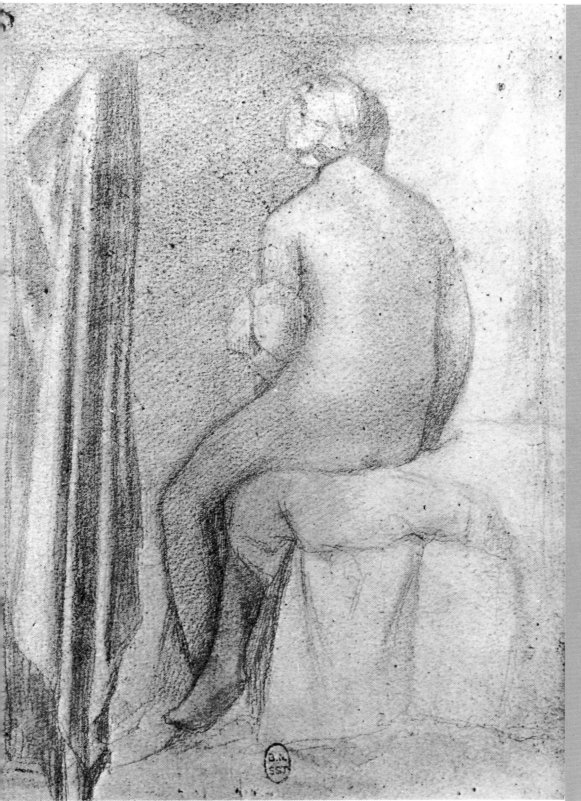

Study after Ingres: Odalisque
with a Turban, 1852.
Pencil drawing, $6^{1}/_{8} \times 4$ in.
Paris, Bibliothèque Nationale,
Cabinet des Estampes.

1

2

3

A man of uncompromising integrity and an artist of genius who worked to the most exacting standards, Degas was a commanding figure in his day. His keen mind left its mark on a mind equally keen, that of Paul Valéry.

Restless, unsure of himself, always alive to the gap between what one aims at and what one achieves, he dedicated his life to his art, except for the time devoted to his friends and to the sights and scenes necessary to his inspiration. Shut-ting himself up in his studio as if in a sanctuary, he let no one in but his models and a few favored friends. He had little desire to show his work—"Painting," he said, "belongs to one's private life"—and he only exhibited along with other painters, first at the Salon, then with the Impressionists. The public could always, of course, see a few new works in the galleries, but Degas held only a single one-man show in his lifetime, when he exhibited twenty-six

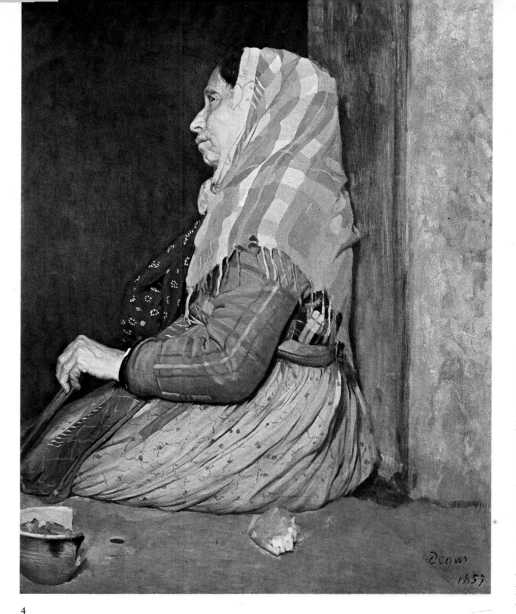

4

pastel landscapes in the fall of 1892. In his studio he experimented with every technique and medium, straining his ingenuity to discover the methods of the old masters and to use them for his own purposes, continually creating new obstacles for himself. "Difficulty— that's all that there is!"

Self-doubt and self-discipline, restlessness and firmness of purpose, the taste for reality and a search for the truth behind it: these were some of the contradictions grappled with by this great artist of so stern and so unbending a character. His sharp, witty sayings sometimes hurt other people's feelings (although some of them reveal a tender side and generous admiration); often they reflect his own inner conflicts rather than any quarrel with others. "I was, or I seemed to be, harsh with everybody, through a kind of incitement to brutality which came from my doubts and my bad temper. I felt so unprepared, so ill-equipped, so weak, whereas it seemed to me that my calculations on art were so right. I was sullen with everybody and with myself."

Hard on himself and hard on others, unsparing in his efforts to achieve

perfection in art, yet always beset with difficulties and misgivings in a struggle which, all the while, was a struggle against himself—how is one to account for such a temperament?

Edgar-Germain-Hilaire de Gas was born in Paris on July 19, 1834. His paternal grandfather had fled Paris in 1793 during the Terror, after his fiancée had been guillotined as a royalist; emigrating to Naples, he founded a bank there and married a middle-class Neapolitan girl, Aurora Freppa. Edgar's father Pierre Auguste de Gas married Célestine Musson in 1832; she was a young Creole from New Orleans who had been brought by her parents to France to complete her education. Edgar, the first-born, was followed by two boys who died in infancy, then by Achille, René, Thérèse, and Marguerite. As the family grew, they moved from Rue Saint-Honoré to Rue d'Assas and finally to 37 Rue Madame, not far from the Lycée Louis-le-Grand, where Edgar went to school. He was only thirteen when his life was saddened by the death of his mother in 1847.

Auguste de Gas, manager of the Paris branch of the family bank, was a man

of cultivated taste, fond of music and painting. He was friendly with such well-known collectors as Lacaze, Marcille, Soutzo, and Édouard Valpinçon, who was a friend of Ingres and owned his *Odalisque with a Turban*. Monsieur De Gas took his son to see these collections and often visited the Louvre with him. In 1852 he moved from Rue Madame to 4 Rue Mondovi, near the Tuileries. In one room of that apartment Edgar de Gas, increasingly attracted by drawing and painting, set up his first studio, after finishing his schooling at the Lycée. (Edgar de Gas later began signing his work *Degas*, as one word. His brothers kept the aristocratic *de* to which they were entitled.)

After studying art in the morning under Barrias, Degas would go in the afternoon either to the Cabinet des Estampes, where with pencil in hand he pored over prints by Mantegna, Dürer, Rembrandt, and Goya, or to the Louvre, where he particularly admired the works of Giotto, Uccello, Luca Signorelli, Clouet, Le Sueur, and Holbein and began copying them. He did not stay long in Barrias' studio and also broke off the law studies which he had begun about the same time at his father's urging. In 1854 he enrolled in the studio of Louis Lamothe, a pupil of Ingres, acting on the latter's advice after Ingres had been consulted by Édouard Valpinçon. Lamothe taught him the guiding principles of his master: the primacy of drawing, the love of pure, incisive line, the importance of craftsmanship and of working from memory, and respect for the old masters. Degas only met Ingres himself two or three times, very briefly, in 1855; Ingres was then seventy-five, Degas twenty-one. His early self-portraits show an aloof, melancholy young man, and portraits of his brothers and sisters made at that time convey the same impression. Is this perhaps the sadness of motherless children or the result of a too-strict upbringing? But

1 Giulia Bellelli, 1859-60. Sketch in oil
thinned with turpentine on ocher
paper, 14¹/₈ × 9⁷/₈ in. Private collection.

2 Giovannina Bellelli, 1859-60. Study in
colored crayons, 11 × 7¹/₂ in.
Private collection. (Photo Routhier)

3 Study for "The Bellelli Family,"
1859-60. Oil sketch on paper mounted
on canvas, 18¹/₈ × 11³/₄ in.
Private collection. (Photo Durand-Ruel,
Paris)

4 The Bellelli Family, 1860-62. Canvas,
78³/₄ × 98¹/₂ in.
Paris, Musée du Louvre.

2

1

3

old masters than from copying antique plaster casts. But at the École he met the engraver Tourny and Léon Bonnat; he also fell in again with Fantin-Latour, whom he had met in the Louvre, and Delaunay, to whom he had been introduced in Lamothe's studio. His life that year was divided between art school in Paris, his friendships, a further trip to Italy (this time via Montpellier, Sète, and Nîmes), and the musical evenings in his father's apartment. From now on he went regularly to the Opera, where he heard Adelaide Ristori and greatly admired her voice, attitudes, and figure: "When she runs, she often has the very movement of the Victory statue of the Parthenon."

Until 1860 he paid yearly visits to Italy. In Naples and Rome in 1856, he painted a portrait of his cousin Giulia Bellelli, copied numerous old masters, and did drawings from live models and also some landscape sketches in pen and ink wash, in the spirit of Claude Lorrain. He did many more of these the following year, first in Florence, then in Rome, where he found his friends from the École des Beaux-Arts studying art at the Villa Medici. In these years of unremitting study he also painted some pictures of his own, portraits of relatives and friends or figure paintings on stock genre topics freshly observed, such as the *Old Italian Woman*, still Ingresque in its style, or the *Roman Beggar Woman,* more freely handled and not so much "picturesque scenes" in the spirit of Léopold Robert as attempts to record reality. He wished to convey the pulsing force and energy of life itself, as he successfully did in the *Self-Portrait with a Hat*, an etching done in 1857 with striking authority. His travel diaries of 1858, when he went by carriage from Rome to Florence, stopping on the way at Orvieto, Perugia, Arezzo, and Assisi, reveal his fascination with and sharp eye for the details of real life, a quality he also appreciated in the old masters. He

they all had a certain natural gravity, visible in their very similar features: a long face, very prominent forehead, wondering eyes under high, strongly marked brows, and finely chiseled lips with a hint of sullenness.

In 1854 he had gone to Italy for the first time, on a visit to his grandfather in Naples. His travel notes, with their vivid detailed comments on sea, sky, and places, show a true painter's eye for colors and forms. In 1855 he entered the École des Beaux-Arts, with the backing of Lamothe. But this was little more than an interlude; he gained much more from the Louvre and direct study of the

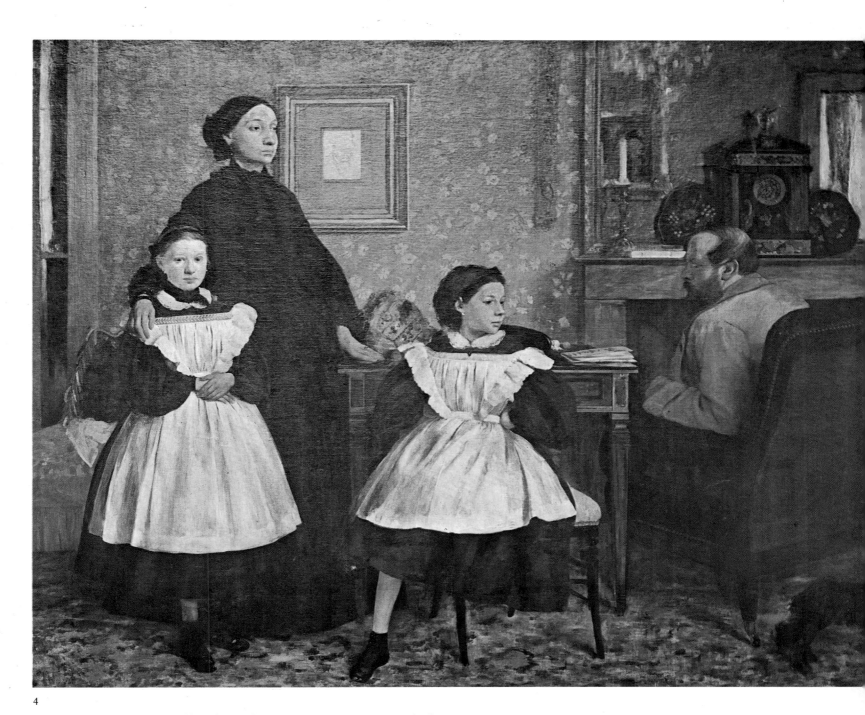

4

noted Signorelli's "love of bustle" and the "amazing grasp of expression and sense of drama in Giotto." "Those men embraced life, they did not repudiate it. And Le Sueur is one of them. May I be one of them, too!"

How was he to reconcile these two apparently contradictory tendencies, his veneration for these artists of the past who "embraced life" and his eagerness to be himself and record what he saw of his own time? This is the problem of

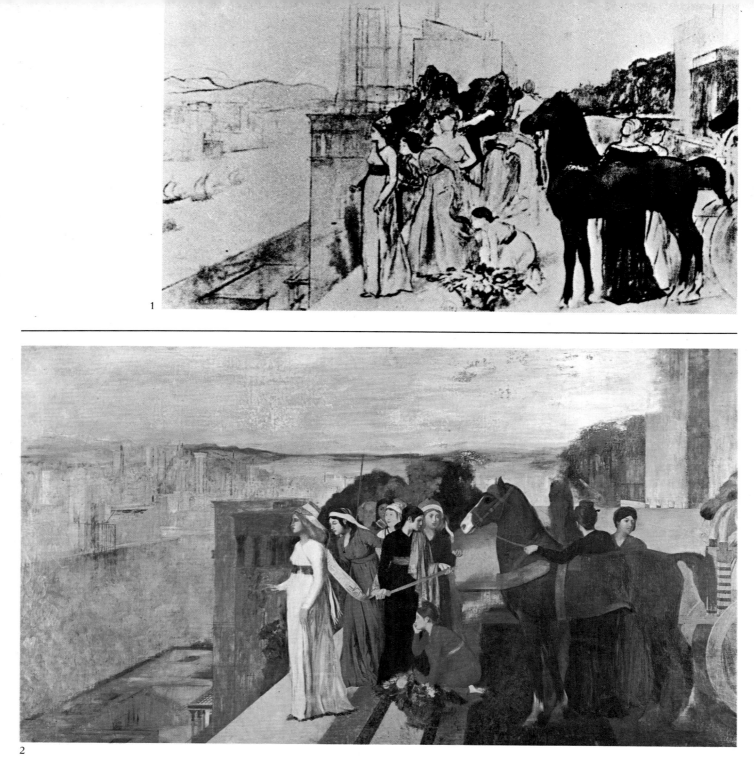

1

2

every young artist, but it was felt by Degas with unusual intensity: "Ah, Giotto, let me see Paris; and you, Paris, let me see Giotto!" "I am going to enter again into the stir and movement of Paris. Who knows what will happen? But I will always be an honest man." Degas kept that resolution. But before returning to Paris he stopped in Florence in early August 1858. His aunt Baroness Bellelli (Laura de Gas had married Baron Bellelli of Naples, who had moved to Florence) was then in Naples at her father's deathbed and did not return until September with her two daughters. (René-Hilaire de Gas, Degas' grandfather, died in early September 1858.) Degas decided to wait for her and to make the most of his stay in Florence, where he found Gustave Moreau, whom he had known in Rome. Perhaps he was already turning over in his mind the idea of a large family portrait of the

Bellellis, who had received him so hospitably. He had done a portrait of Giulia in 1856, then one of Giovannina. Now, on their return in September, he made a series of pastel sketches of his cousins and aunt. But he did not work them up and complete the family portrait until well after his return to Paris in April 1859, in a new studio in Rue Madame. Outwardly the picture is almost classical in its strict design and careful workmanship, with a subject reminiscent of Raphael, Bronzino, the Dutch and French masters of the seventeenth century, and certain Ingres pencil portraits. But underneath there are all sorts of bold touches. The sitters, except for one of the little girls, do not look at the painter; each one has a natural attitude of his own. Baron Bellelli is shown almost casually, from behind, half turning in his easychair. The distinct grid of vertical and horizontal lines

formed by the doorway, the picture frame, and the mantelpiece and mirror is offset by the soft blue flowered wallpaper and the deliberately blurred rendering of the rug pattern. The girls' pinafores, opening out like two white butterflies, set off the dark pyramid formed by the figure of Baroness Bellelli. An instant in the everyday life of this family has been caught and held, in random natural attitudes, not in a contrived pose.

Simplicity, yes—but not familiarity: Degas' inborn distinction makes itself felt in all his portraits. They are psychological studies, in the French tradition of Clouet. Thus, in the Bellelli portrait, one senses the inner life of each of these grave and silent figures. Degas painted many self-portraits at this time, searching his own face and looking into himself. Little by little he found himself as a painter, and the emerging

colorist appears in the brighter tones. Some details reveal a knowledge of photography—casual attitudes suggestive of a snapshot, figures or objects abruptly cut off by the frame, or a markedly off-center composition like that of the *Woman with Chrysanthemums.*

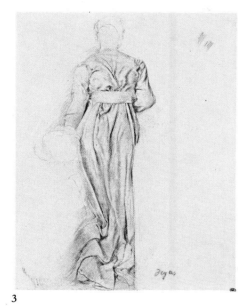

3

A number of a daguerreotypes that have come to light were very likely used by Degas as the starting point for some of his portraits. For him they represented a new way of seeing, suggesting unusual layouts and fresh angles of vision. They prompted him to make the experiment of contraposing a woman caught by the camera in a mood of reverie, unmindful of everything around her, with a girl delineated by another artist in an everyday occupation, arranging flowers as in Courbet's *Trellis*, of slightly earlier date than the *Woman with Chrysanthemums.* Purposeful presence in the one case, meditative or dreamy absence in the other.

In September and October 1861 Degas had spent several weeks in Normandy with his friend Paul Valpinçon, son of the collector, at the Château of Ménil-Hubert, near the Le Pin stud farm. From this time date his first studies of horses and jockeys, the *Gentlemen's Race* and *Departure for the Hunt.* While still generalized treatments of a newly discovered theme, these scenes are lively and spirited: in one, we are struck by the colorful tunics of the jockeys in the

4

foreground and beyond them the crowd of spectators on the green, with the ladies' crinolines and parasols; in the other, the golden-hued countryside setting off the red coats of the huntsmen moving about on their mounts.

The next step was to infuse some of that life into a series of historical scenes. During the years 1860-1865, while painting the *Bellelli Family* and other portraits, *Woman with Chrysanthemums,* and various racing and hunting scenes, Degas also undertook a series of five history paintings, a type of picture still considered to represent the highest form of art at that time. Degas seems to have meant these as a tribute to the masters he admired. As usual in such pictures, the titles sufficiently describe the subjects treated: *Spartan Boys and Girls Exercising, Semiramis Founding a City, Alexander and Bucephalus, Jephthah's Daughter,*

and *Scenes of War in the Middle Ages* (or-*The Misfortunes of the City of Orléans*).[1] Considered in detail, these works have some fine and even moving qualities, but as a whole they are a failure. Degas tried hard to breathe life into these fictions, but the general effect remains contrived. There is no vital connection between all these figures and groups. The preparatory studies, so vigorous and admirable in themselves, somehow lost that vigor when combined on canvas. The pulse of life is absent from the overall composition. But there remains an impressive series of sketches and studies of nudes, busts and figures, of draperies, and of archers and horsemen, in watercolor, wash and red chalk, in pencil and crayon, highlighted with pastel or white on tinted paper—disparate and beautiful, perhaps too perfect singly to be fitted together cohesively. Some of these drawings are as fine as those of Florentine or German Renaissance masters; some are as deft and evocative as those of Watteau. "He won't take any time off to relax, but works unremittingly," said René de Gas of his brother in 1863. His exertions bore fruit, and the mastery of his art Degas thus acquired was gradually to be applied to what had become his chief concern—recording the life he saw around him. In doing so, he joined a movement that had been gathering momentum for several years.

While copying in the Louvre in 1862, Degas made the acquaintance of Manet. Both upper-class Parisians, well-educated and of about the same age (Manet was then thirty, Degas twenty-eight), they quickly became friends. A music

1 This may have been meant to depict New Orleans (La Nouvelle-Orléans), for the contraction "Nlle" was perhaps misread as "Ville" (City) in 1918 at the Galerie Georges Petit. (See note by Mme Jean Adhémar, *Gazette des Beaux-Arts,* November 1967.)

1 Gentlemen's Race, Before the Start, 1862. Canvas, 18$^7/_8$ × 24 in.
 Paris, Musée du Louvre. (Photo Musées Nationaux)

2 Gustave Courbet: The Trellis, or Young Woman Arranging Flowers. Canvas, 43$^1/_4$ × 53$^1/_8$
 in. Toledo (Ohio), The Toledo Museum of Art, Gift of Edward Drummond Libbey.

3 Woman with Chrysanthemums, 1865. Canvas, 29$^1/_8$ × 36$^1/_4$ in. New York, The
 Metropolitan Museum of Art, Bequest of Mrs. H. O. Havemeyer, 1929.

enthusiast, Manet was invited to the private concerts organized by Degas' father in their Rue Mondovi apartment. And Degas got into the habit of going to the Café de Bade, then the Café Guerbois, where Manet gathered together his friends in the evening: Bazille,

Fantin-Latour, Pissarro, Sisley, Renoir, Cézanne, Duranty, Théodore Duret, and Zola. Manet was resolutely modern; while still a student he had written in the margin of a notebook: "One must be of one's time and paint what one sees." Manet's example did much to convert Degas wholeheartedly to modernism.

Degas now followed up the *Bellelli Family* and *Woman with Chrysanthemums* with a long series of portraits. Their draftsmanship, assured and vivacious, is on a par with his keen powers of observation and admirably conveys individual ex-

pression; color, too, is used to good effect. While admiring the classically oriented Ingres, Degas was equally attracted by that older master's great rival Delacroix, the supreme colorist and Romantic, who had died in 1863. As always his sitters were friends or relatives, whose character he tried to bring out more tellingly by showing them in their everyday settings. "Do portraits of people in familiar and typical attitudes, and above all give the face the same kind of expression as the body." The figures are shown amid the furniture and objects of the rooms in which they live. These are scenes of homelife, with light gleaming in mirrors and playing over the skin and clothing: "Remember the pinkish ivory tints of these women's complexions with their dark gowns of green or black velvet." He shows us not so much the lamps at

evening as the soft glow of the lamplit room: "Work at evening effects, lamps, candles, etc. The point of the thing is not so much to show the source of light, but the effect of light." Certain details, an embroidered fabric or an ornate frame on the wall, are rendered with the minute accuracy of a Dutch master. But these glimpses of real life also recall Japanese art; Oriental art had come into vogue now that the ports of China and Japan were once more open to trade with the West.

The engraver Félix Bracquemond, a friend of Degas, had discovered the bold prints of Hokusai about 1856. Eugénie de Montijo, upon becoming Empress of France in 1853 by her marriage to Napoleon III, had not only made Spain fashionable (as reflected more in Manet's art than in Degas') but had also contributed by her personal preference to the vogue for Chinese art, shown in the success of a shop opened in 1861[1] in Rue de Rivoli; this was "La Porte Chinoise," which became well known to artists and to such writers as Zola, Baudelaire, and the Goncourts. What attracted Degas in Japanese prints was their novel and inventive layouts, which went well with his own experiments and confirmed certain discoveries he had made through photography; he also found a highly original and expressive handling of gestures and movement in Japanese graphic art.

Gestures express personality and character; they extend the individual and give him his dimension in space. Degas was also intent on capturing the attitudes and movements peculiar to given professions.

Through his friend Désiré Dihau, bassoonist at the Opera, he met a number of musicians and began to observe their way of playing and the expressions on their faces as they did so. "Do a series

1

1 The date given in the *Journal* of the Goncourt brothers.

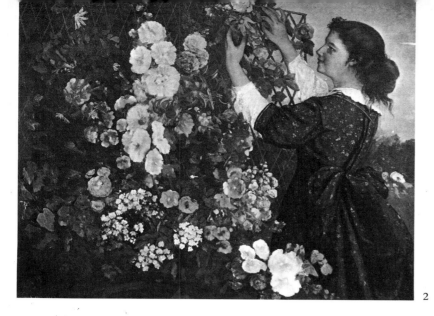

2

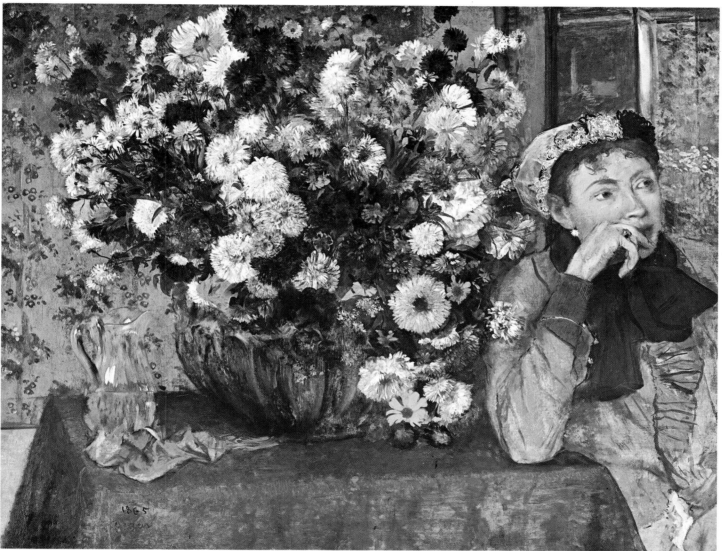

3

on instruments and instrumentalists, their shapes, the twisting of a violinist's hand and arm and neck, for example; the swelling and hollowing cheeks of a bassoonist or an oboist." These notes give an idea of what he aimed at and suggest the difficulty of achieving it, for after studying each instrumentalist separately, he went on to group them together in an attempt to capture the impression created by a whole orchestra in action. The *Musicians in the Opera Orchestra* also illustrates his new experiments in picture design: it gives but a fragmentary glimpse of the on stage performance, thereby heightening the sense of participation and reality. Such a scene rendered in its entirety would be less immediate than this fragment shown in close-up. The double-bass player is depicted unawares from behind, for instance, and the effect is all the more arresting; he is given unexpected prominence, and the neck of his instrument juts upward, as large as life, and cuts into the scene on stage, where the bodies of the dancers are but partially visible in the glare of the footlights. We are made to feel the "compelling strangeness" noted in these works at the time by J. K. Huysmans. Degas toyed with the idea of a series of pictures on "bakeries and bread," also on "steam, smoke, and locomotives" (soon to be painted by Monet). He was already drawing laundresses and women ironing. In Normandy he made further sketches and studies of jockeys and horses, and from these worked out the

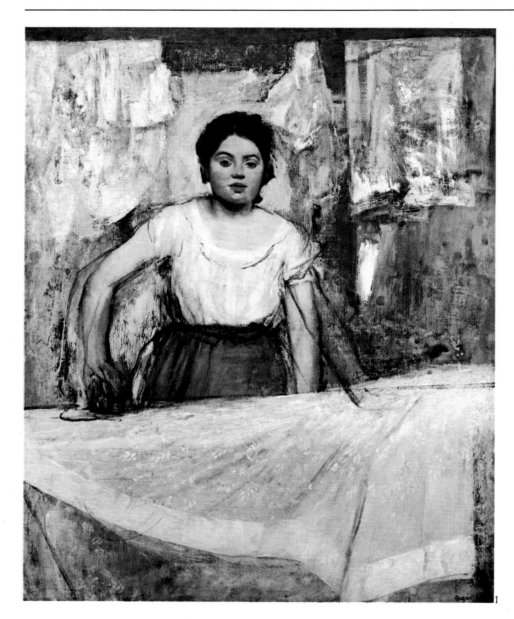

1 Laundress, 1869. Canvas, 36¹/₄ × 28³/₄ in. U.S.A., Private collection.

2 Musicians in the Opera Orchestra, c. 1869. Canvas, 22 × 18¹/₈ in. Paris, Musée du Louvre.

air and changing light, suggesting boats in the distance or figures on the shore with quick dabs of color. In these small pastels he manages to convey a sense of great distance. "Never haggle with nature," he said. "Of course, it takes courage to approach nature head on, in her broad planes and main lines, but it is cowardice to tackle her by way of facets and details."

The public knew very little of all this activity. From 1865 to 1870 Degas regularly showed one or two pictures at the annual Salon. These passed unnoticed, however, and he was more successful in Brussels, where he visited in February 1869 with his brother Achille. For all his originality of design, his handling of paints was still classical. While Degas was showing his *Scenes of War in the Middle Ages*, some portraits, and a few pictures of horses, Manet was creating a sensation with *Olympia, Déjeuner sur l'Herbe, The Fifer,* and *The Balcony.* It is difficult to compare the two painters at this stage; they were very different in temperament. Manet, trusting to instinct, believed "the only right thing to do is to paint what you see straight off." More intellectual, Degas was continually revising his work: "Of inspiration, spontaneity, temperament, I know nothing; what I do is the result of reflection and study of the great masters."

Manet, thoroughly sure of his hand and eye, advanced by leaps and bounds while Degas, scrupulous to a fault, plotted out everything in admirable sketches but multiplied the difficulties in his way, and thus progressed slowly. He would spend the whole day at work in his studio, accustomed to a solitude which now seemed increasingly necessary to him. But in the evening he liked to meet and talk with the painters and writers who gathered at the Café Guerbois, for his solitary nature nonetheless needed human contact and the stimulus of Paris, and all his life he kept up his friendships.

finished pictures in his studio. This was always his way: observation and jottings provided the starting point and the guidelines for pictures later done from memory in the studio. The final effect of surprise or casual spontaneity was based on long and thorough preparation.

On the Channel coast in 1869, at Boulogne, near the Manets, and at Saint-Valéry-sur-Somme and Beuzeval, he made some pastel studies of the dunes and beaches Boudin loved to paint. With great finesse he rendered the moist

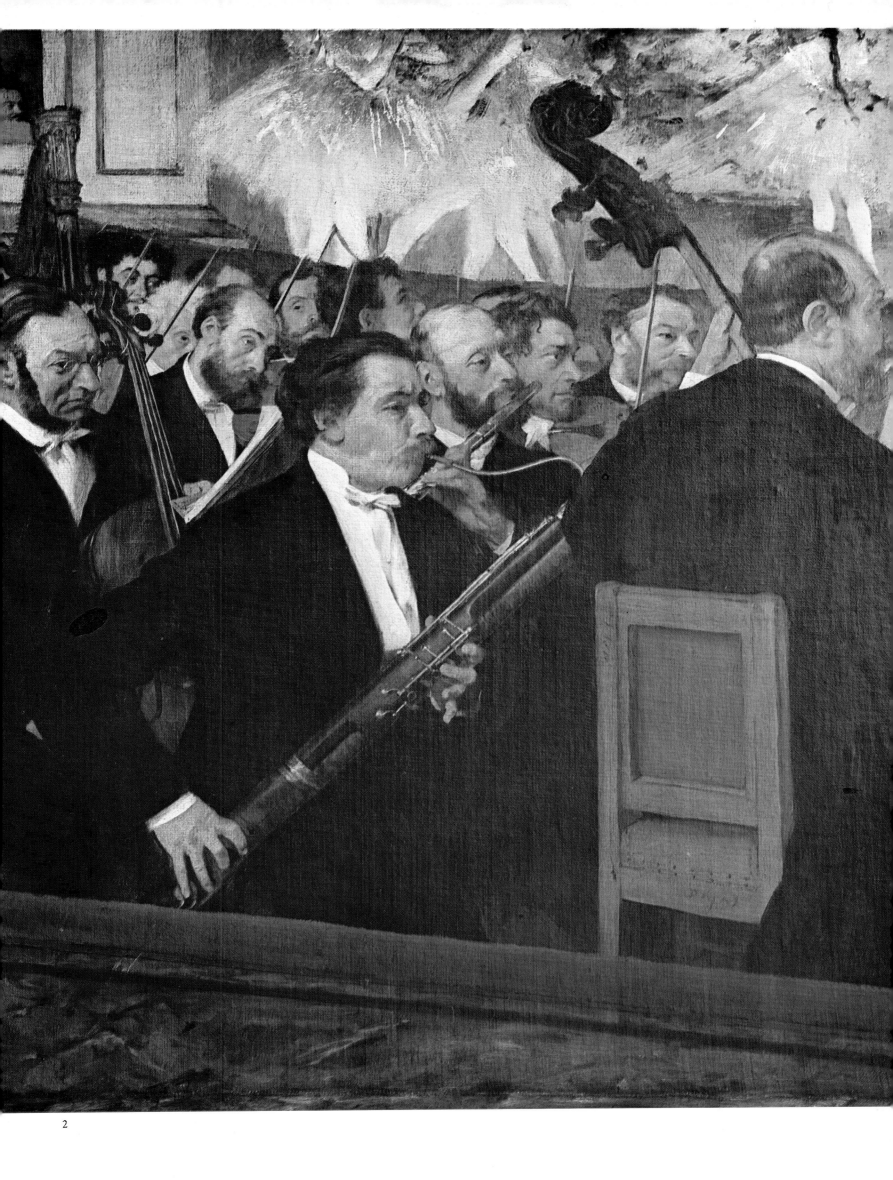

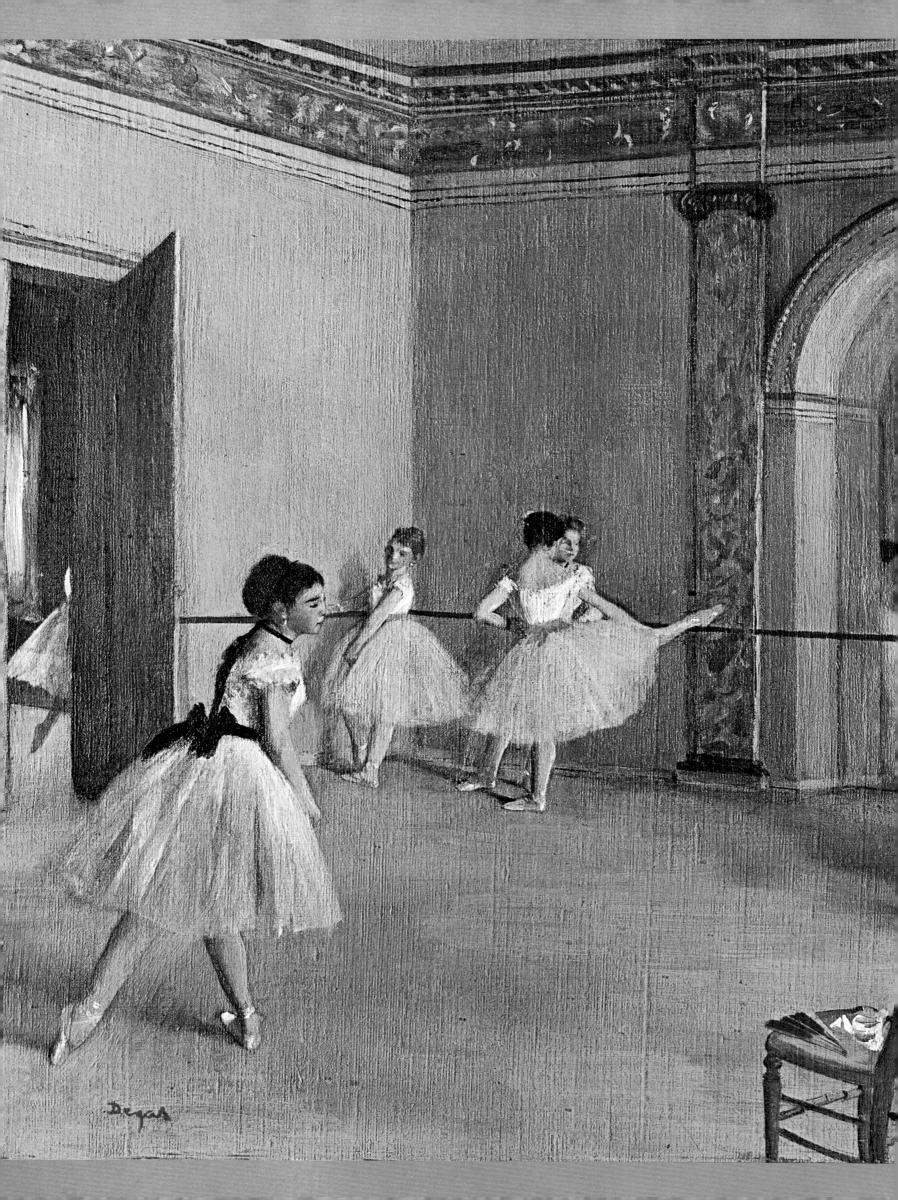

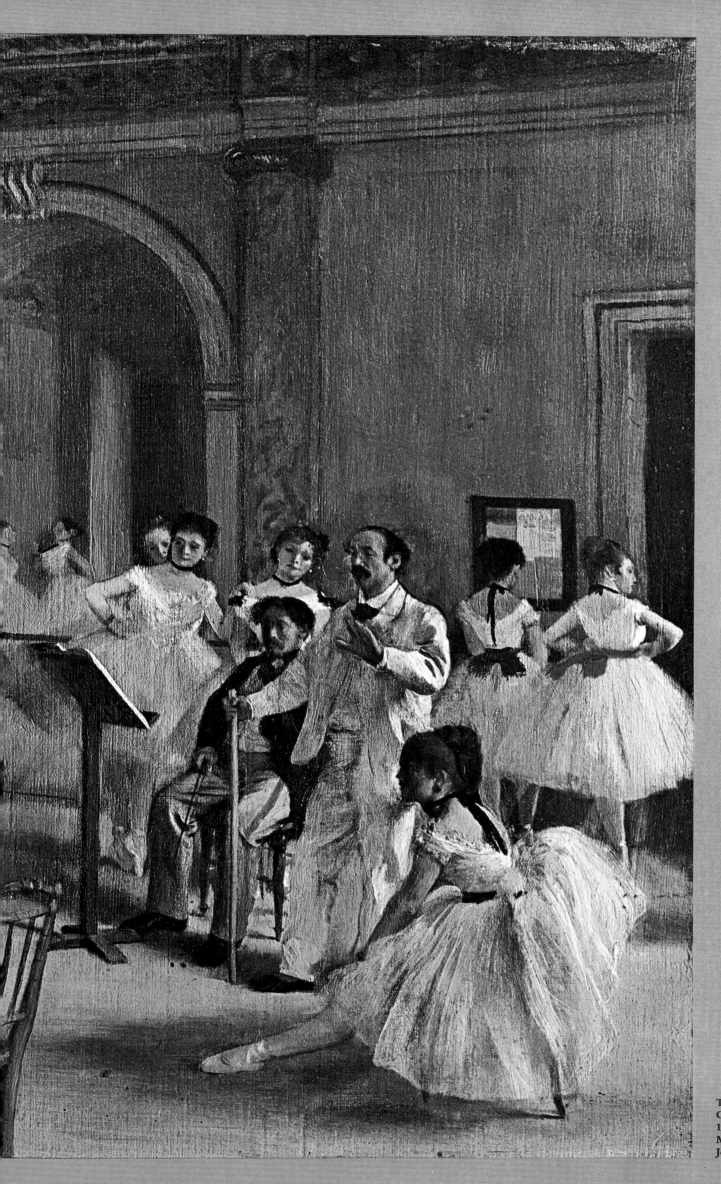

The Dance Foyer at the
Opera, 1872. Canvas,
12⅝ × 18⅛ in. Paris,
Musée du Louvre. (Photo
Josse)

Of medium height and slender, as described by his friend Paul Lafond, "with a high, broad, bulging forehead crowned by silky brown hair, with bright, sharp, questioning eyes deeply set under high, arching brows shaped like circumflexes, and delicate lips half-hidden behind a light beard," Degas was just thirty-six when war broke out in 1870. Volunteering, like Manet, he served in an artillery unit commanded by Henri Rouart, his old schoolmate at the Lycée Louis-le-Grand. They formed close ties and the Rouarts, both Henri and his brother Alexis, became like a second family to Degas. Though disheartened by the French defeat and the death of one of his friends, the sculptor Cuvelier, who was killed in action like Bazille, Degas went back to work with

a will, taking up again the themes of horses and musicians. In the racing pictures *False Start* and *Jockeys before the Grandstands*, both apparently begun in 1869, the linework is much sharper than in his previous scenes of this kind. Here the artist has carefully rendered the exact outlines of jockeys and horses in sunlight and effectively contrasted them with their cast shadows on the ground. In the new series of studies of musicians, too, he contrasted the prevailing black and white of the frock-coated instrumentalists, seen from behind and in shadow, with the brightly lit dancers in pink and white amid summer scenery. That same year (1872) he painted the *Dance Foyer at the Opera*, a small canvas in golden and silvery tones set off by a few spots of ocher and blue; several

groups of dancers are practicing in a large room whose background pattern of doorways and wall moldings is carefully delineated. His brother René may have been referring to this when he wrote in a letter: "He is painting a dance rehearsal which is charming. I will have a large photograph made of it." René de Gas, who since 1865 had been engaged in the cotton business in Louisiana with his uncle Michel Musson, was now in Paris for a visit.
"Edgar has matured; there are even a few white hairs in his beard. I dine with him every day. He has a good cook and a charming bachelor's apartment." Degas remained a bachelor and lived alone, but he was not unresponsive to women. On his early trips to Italy he exclaimed:

1 At the Seaside, c. 1869. Pastel,
11³/4 × 18¹/8 in.
Paris, Musée du Louvre, Cabinet des
Dessins. (Photo Musées Nationaux)

2 Photograph of Degas taken during his
stay in New Orleans in 1872.

3 The Cotton Exchange in New Orleans,
1873. Canvas, 29¹/8 × 36¹/4 in.
Pau, Musée des Beaux-Arts.

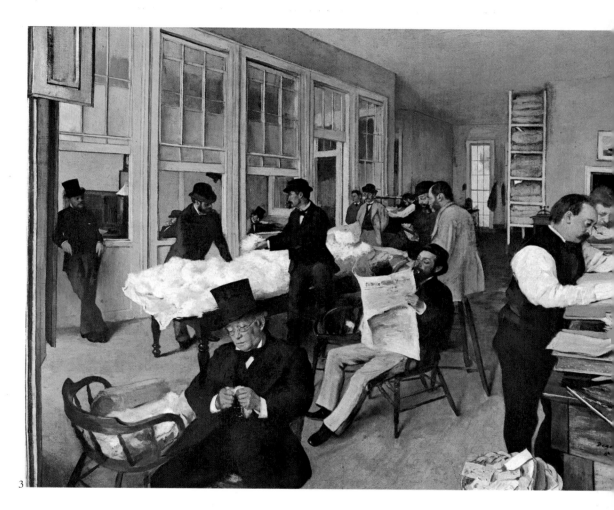

"How many pretty women and girls!" And again: "Pretty girls in the carriage in front of us, one of them my coachman's daughter." He thought, too, of getting married: "If I could find a nice little wife, simple and quiet, who would understand my crazy ideas, and with whom I could live an unpretentious, hard-working life. Is that not a fine dream?" But he was a man continually torn between extremes—"Those one loves the most are those one could hate the most," he wrote at twenty-two— and his ideal of womanhood was probably too demanding. Full of contradictions, prudish and passionate, shy and intransigent, he lacked self-assurance and spontaneity. He may have been embittered by an unfortunate love affair. Berthe Morisot, who had met him at the Manets', wrote to one of her sisters in March 1869: "Degas came and sat beside me as if he intended to woo me, but his wooing was limited to a long commentary on the proverb of Solomon: Woman is the desolation of the righteous man."

Feeling the weight of solitude and years of hard work, and dismayed by France's crushing defeat in the war, Degas decided on a change of air, after the example of his friends Manet and Monet, then traveling in the Low Countries, and Berthe Morisot, who had gone to Spain. When his brother René sailed back to Louisiana in October 1872, Degas went with him and spent six months in New Orleans. Life there was simple and pleasant in the house of Michel Musson, among the romping children of René de Gas and his young wife Estelle Musson, their cousin, and Degas' other brother Achille, who had joined their uncle as a partner in the family cotton business. Degas was delighted with everything he saw in New Orleans. And as he had done in Italy with the Bellellis, he undertook a series of portraits of the whole family, especially Estelle, who was very pretty. He brought his uncle and brothers together in the *Cotton Exchange in New Orleans*, among a group of buyers and sellers, all in easy yet carefully calculated attitudes in a still classical composition, set against a modular grid of windows, partitions, and shelves. The gleaming highlight of a glass door at the far end of the room recalls a similar effect in Dutch interiors. A few colored scraps in a wastepaper basket and a sheet of blue paper on the desk brighten up this muted picture. One is reminded of the small still-life details Manet introduced into his figure paintings.

But, "while novelty captivates, it soon palls," and though Edgar had enjoyed his stay in New Orleans, he was delighted to get back to his Paris studio at the end of March 1873. "I don't want to see anything more but my own little corner and dig there religiously. Art does not spread out, it summarizes."

Traces of tension

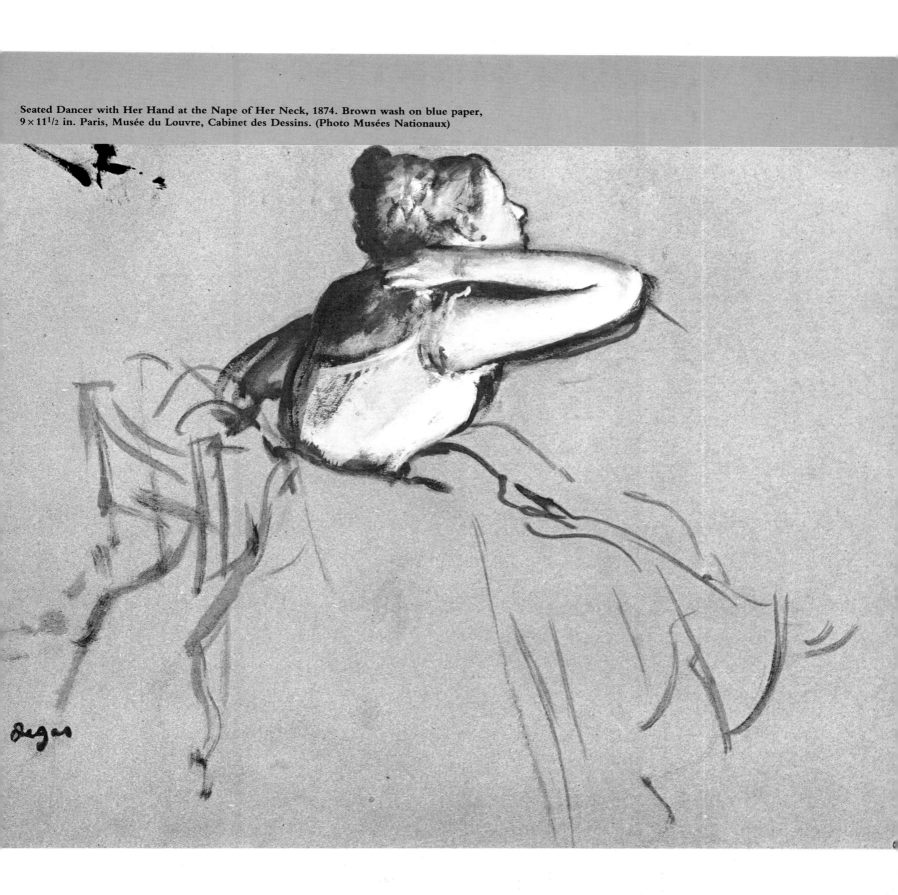

Home again in his Paris studio and apartment at 77 Rue Blanche, Deġas resumed his theater-going habits. Accustomed as he was to working out his ideas in trial sketches, there was a peculiar fascination for him in following a dancer's exercises, her studies of balletic movements and gestures, and the unceasing practice required to make her stage artifice look natural. There could be nothing more challenging for the artist than rendering movement, catching the transition from one attitude to another, the instant between a fixed pose and movement when the dancer is off balance. What he had to show was the transformation undergone by the body in that fleeting instant. Although the ballet dancer may seem to stand out as the most apt symbol of Degas' art, others among his favorite themes would do just as well: jockeys, acrobats, horses, anything connected with a specific profession that is at the same time an art, one which calls for order, discipline, and precision. He continued his study of the laundresses and women ironing he saw in their shops as he went down the street, and soon took up the theme of milliners as well. His aim was to observe, analyze, and faithfully record the gestures and atmosphere peculiar to each of these occupations. In doing so, his analytical precision was so great that Jacques-Émile Blanche once likened Degas' outlook as an artist to that of an engineer.

But that precision was tempered by genuine emotion and a highly refined

1

2

1 Portrait of Léopold Levert, c. 1874. Canvas, 25⅝ × 21¼ in. U.S.A., Private collection.

2 Study for "The Rape," c. 1874. Oil thinned with turpentine on grease paper mounted on canvas, 11¾ × 8¼ in. Private collection.

3 Carriage at the Races, 1870-73. Canvas, 14¼ × 21⅝ in. Boston, Courtesy of the Museum of Fine Arts.

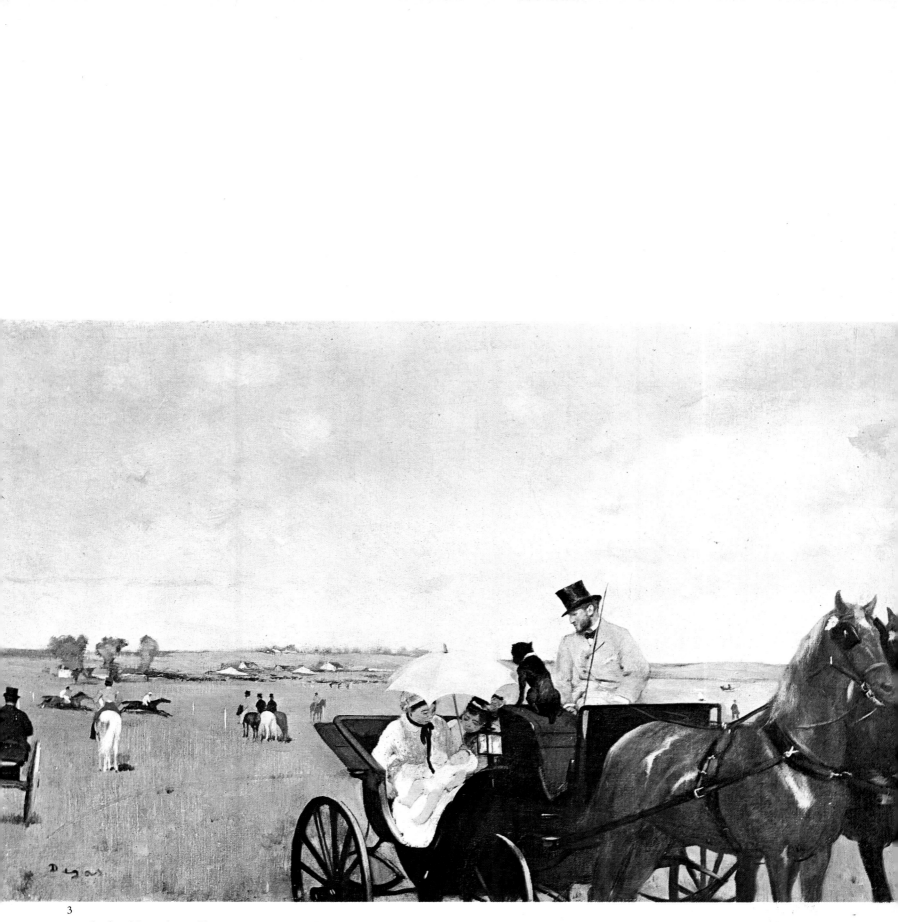

3

touch, for this analyst of human occupations was truly a poet in his appreciation of subtle detail. Edmond de Goncourt paid him a visit in February 1874: "I spent all yesterday afternoon in the studio of a strange painter named Degas. After many ventures and attempts, after striking out in all directions, he has become enamored of the modern, and in the modern vein has set his sights on laundresses and dancers. He brings before our eyes laundress after laundress, in their poses and graceful foreshortenings. ... He speaks their language and can technically explain the *downward* way of pressing, the *circular* way of pressing, etc. Then the dancers file past.

... The painter shows you his pictures, commenting on them and explaining his comments every now and then by mimicking a choreographic figure or by imitating what the dancers call their *arabesques*. And it is really quite amusing to see him, standing on tiptoe with rounded arms, as he interweaves the aesthetic of the dancing master with the aesthetic of the painter, talking of the 'tender smudginess' of Velázquez and the 'silhouettiness' of Mantegna. A very original fellow, this Degas, morbid, neurotic, ophthalmic, so much so that he is afraid of losing his eyesight; but

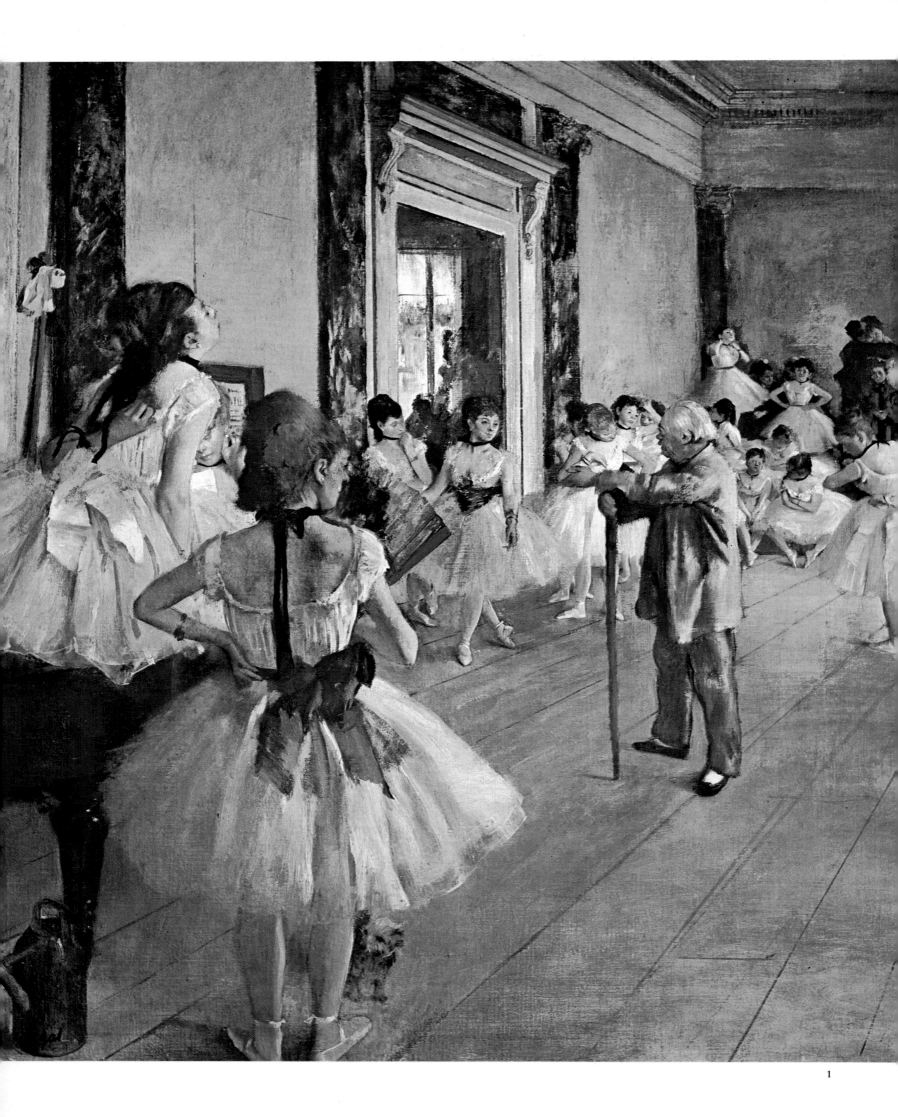

1

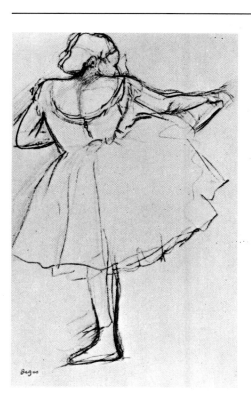

Dancer at the Bar, study for "Dancers at the Bar," c. 1876.
Pencil, 12¼ × 7⅞ in.
Paris, Musée du Louvre.

for that very reason a peculiarly sensitive creature, very aware of the reverse character of things. Up to now, as far as I can see, he is the man who, in transcribing modern life, has best captured the soul of that life."[1]

By now Degas was known not only to artists and writers, but to several outstanding collectors; and he had sold canvases to the dealer Paul Durand-Ruel, whom he met through Monet and Pissarro. After 1870 he no longer exhibited at the Salon—as a show of independence, since he refused to make any concessions to an academic-minded jury, and also out of sympathy with the artists who, like him, had turned to themes from contemporary life and

The Dancing Class, 1874. Canvas,
33½ × 29½ in.
Paris, Musée du Louvre.

were usually rejected at the Salon. They realized their work only stood to gain by being seen in a different context, separate from this stuffy official exhibition. Degas therefore agreed to take part in organizing a separate exhibition, along with Monet (who together with Bazille, as early as 1867, had had the idea of forming a group), Sisley, Renoir, Pissarro, Cézanne, and Berthe Morisot, among others. "The realist movement no longer needs to contend with others. It is, it exists and must show itself as something apart. We must have an exhibition of realists," he wrote to his painter friend Tissot, in trying unsuccessfully to persuade him to take part. Manet too was urged to join them but also refused, feeling that true recognition could only come from the public attending the official Salon. The independents' group exhibition opened on April 15, 1874, and met only with hostility and ridicule; but this occasion gave rise to the lasting term Impressionism, invented by a critic from the title of a picture by Monet.

A second group show was held in 1876. Edmond Duranty, twenty years after his epochmaking article "Realism in Painting," published a long review of this exhibit entitled "The New Painting, in connection with a group of artists exhibiting at the Durand-Ruel Gallery." In it he paid tribute to Degas: "The series of new ideas has taken shape chiefly in the brain of a draftsman, one of ours, one of the artists exhibiting in these rooms, a man of the rarest gifts and the rarest powers of mind. Enough people have profited by his ideas and disinterestedness for justice to be done him here, and for the source on which so many painters have drawn now to be made known, those others who would refrain from revealing it should it please this artist to go on exercising his rare faculties as a prodigal and philanthropist in art, and not as a businessman like so many others."

Of course, the new ideas had not come

from Degas alone; Manet had played a leading part and Duranty was aware of this. But he was partial to Degas, who always backed him up in the passionate discussions among artists and writers at the Café Guerbois and later, after about

1 Edmond de Goncourt, *Journal*, February 13, 1874.

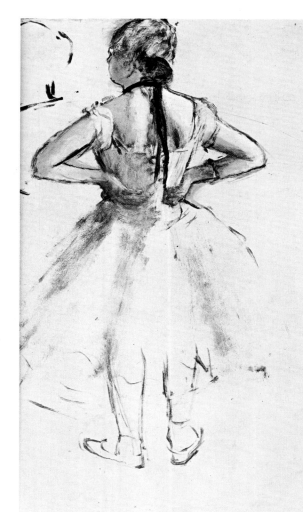

Dancer Seen from Behind, study for "The Dancing Class," c. 1876.
India ink and gouache on pink tracing paper, 15⅜ × 11 in.
Paris, Musée du Louvre, Cabinet des Dessins. (Photo Musées Nationaux)

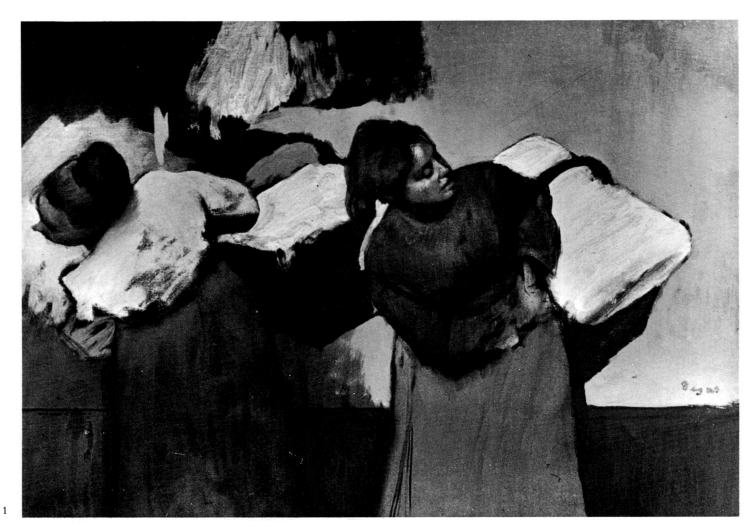

1

1875, at the Café de la Nouvelle Athènes in Place Pigalle. Then, too, it was Degas alone whose prestige was at stake in these group exhibitions, which continued, not without difficulty, until 1886. He was looked up to by all of them. They recognized his intelligence and generous disinterestedness, though they feared his withering irony and unpredictable temper. He still lived alone, sometimes regretting it, sometimes longing for children. "A few children of my own, would it be too much for me?" he wrote to Henri Rouart from New Orleans. For so dedicated and demanding an artist, it seemed out of the question. "There is love and there is work, and we have but one heart."

He went out a good deal, to the theater and racetrack. "Monsieur de Gas himself has phases of sporting elegance," commented Jacques-Émile Blanche. But it was not merely to relax, for he always had his work in mind. At the Opera he kept a constant eye on the dancers, took notes, and made a careful record of tempo and movements, all of which he made good use of in his studio. There he planned his studies, building them up with strict precision in ink or watercolor on squared off paper of different tints (green, pink, or blue), and complicating his means of expression in order to escape the pitfalls of facility and better

1 **Washerwomen Carrying Laundry, c. 1876-78. Oil thinned with turpentine on paper mounted on canvas, 18¹/₈ × 24 in. U.S.A., Private collection.**

2 **Absinthe, 1876. Canvas, 36¹/₄ × 26³/₄ in. Paris, Musée du Louvre.**

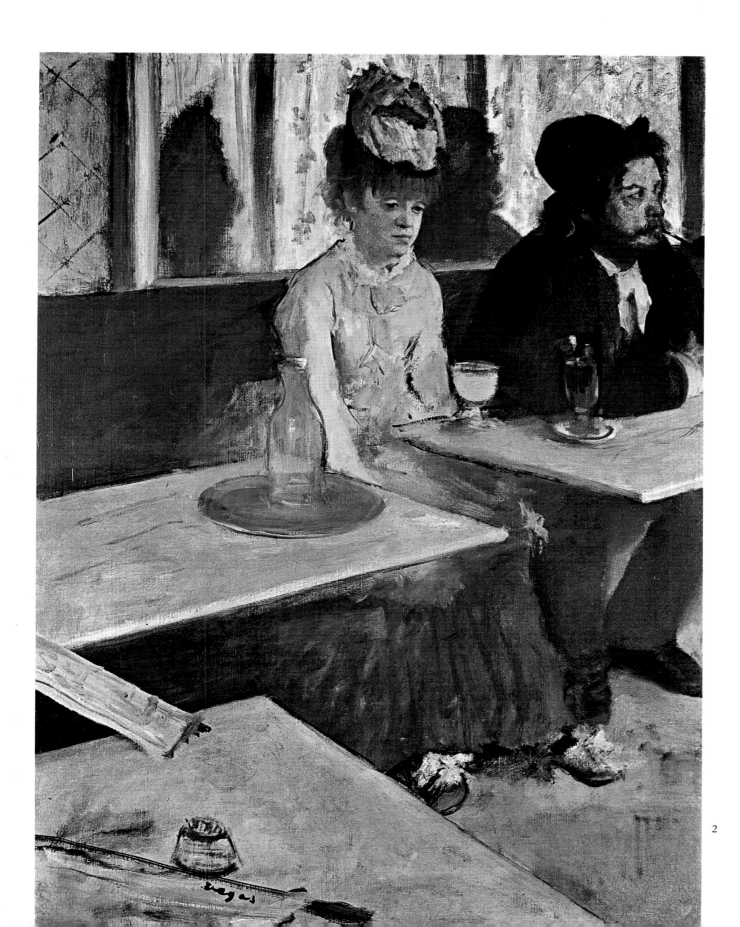

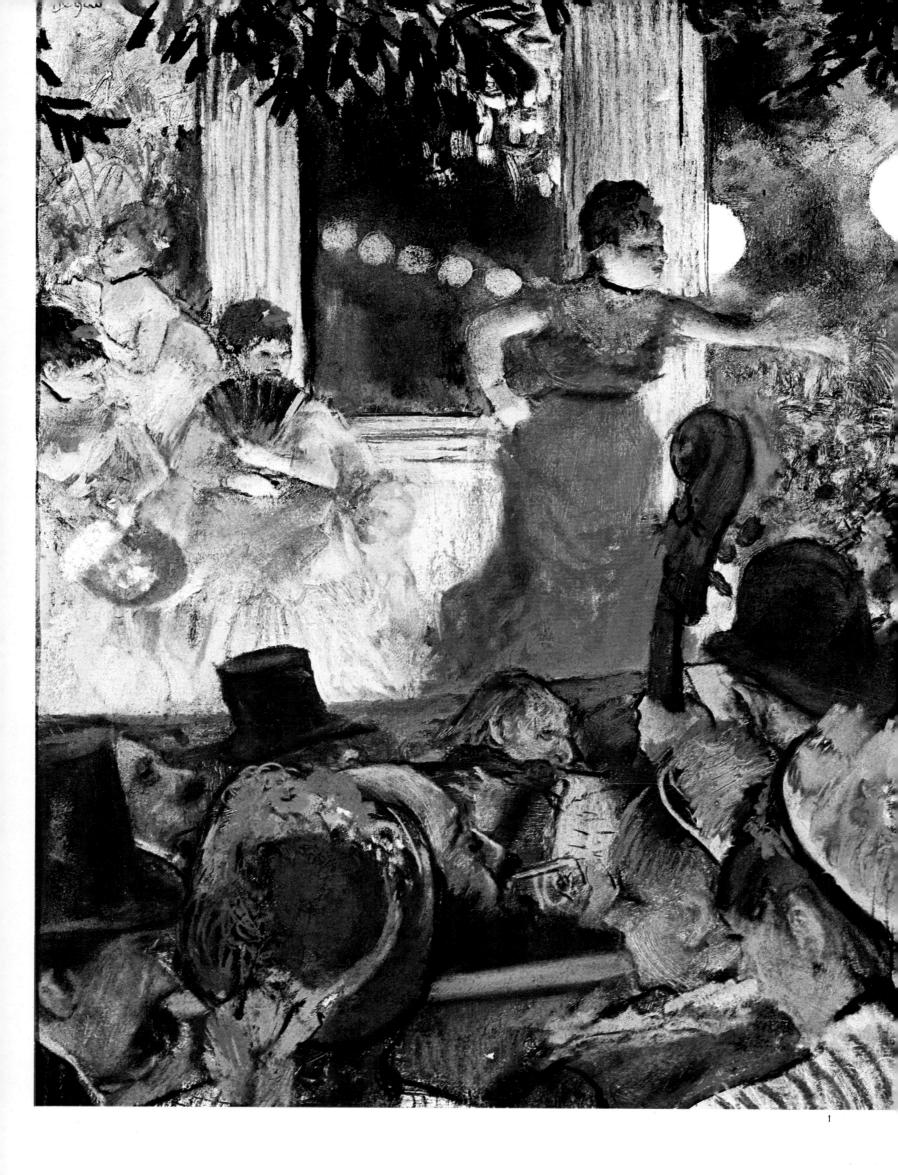

convey his impressions. The drawing came to life among these regular squares like a melody jotted down on a musical staff. Each dancer was carefully modeled with supple lines inscribed in the network of squares which measured out space equally, just as staves divide time into equal lengths. He assembled these figures as he had seen them during a lesson or a rehearsal, spacing out the groups. But what a difference compared with the history scenes he painted a few years before! Now everything was knit together in an organic composition. The pictures of horses (*Carriage at the Races, Racehorses at Longchamp, Amateur Jockeys by a Carriage*) above all illustrate this new conception of space. "Cut drastically," reads an entry in his notebook: figures and objects cut off by the frame and shown in close-up in the foreground strike a contrast with background details and thus heighten the sense of depth. Together with a few beach scenes, these racecourse subjects are Degas' only open-air pictures of any importance. His eyes were too sensitive to glaring outdoor light and were already giving him trouble, as he complained to his brother René in 1872 and to Edmond de Goncourt in 1874. He was soon bored in the country: "How can people live out there?" He loved the city, the continual stir of people in the streets. He was a born observer and psychologist. He kept returning to portraiture, set in interiors that help delineate character and the contrast of personalities. Pictures such as *Pouting, Melancholy,* and *The Rape* are expressions of solitude, of the distance and antagonism between man and woman. (*The Rape* looks like an illustration of some dramatic incident, perhaps a scene from a contemporary novel by Zola or Duranty.) There is a moralist in Degas, and this side of his nature emerges again and again, especially in his choice of certain subjects from contemporary life—the dazed-looking drinkers in *Absinthe*, the *Women*

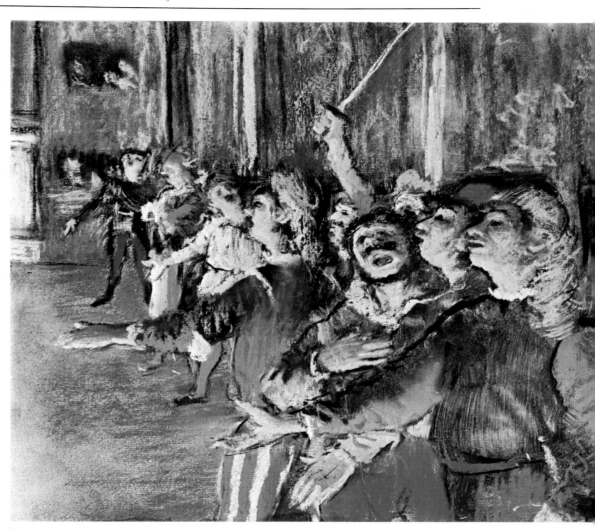

2

1 Café-Concert at Les Ambassadeurs, 1876-77. Pastel over monotype on paper, 14⅝ × 10⅝ in.
Lyons, Musée des Beaux-Arts.

2 The "Supers," 1877. Pastel over monotype, 10⅝ × 12⅝ in.
Paris, Musée du Louvre, Cabinet des Dessins. (Photo Musées Nationaux)

in a Café in the Evening, and the brothel scenes he painted years before Lautrec. But problems of technique and design were uppermost in his mind in all his canvases, pastels, and "monotypes," those "drawings made with greasy ink and printed," following a procedure he had worked out himself. He continual

ly experimented with light effects, not only the glow of lamplight in rooms, illuminating a bed or a flower-patterned wallpaper, but the artificial lighting of the theater. It is one of the key elements in his pictures of music halls, circuses, and theaters. Singers, actors, and supers are lighted from below by the

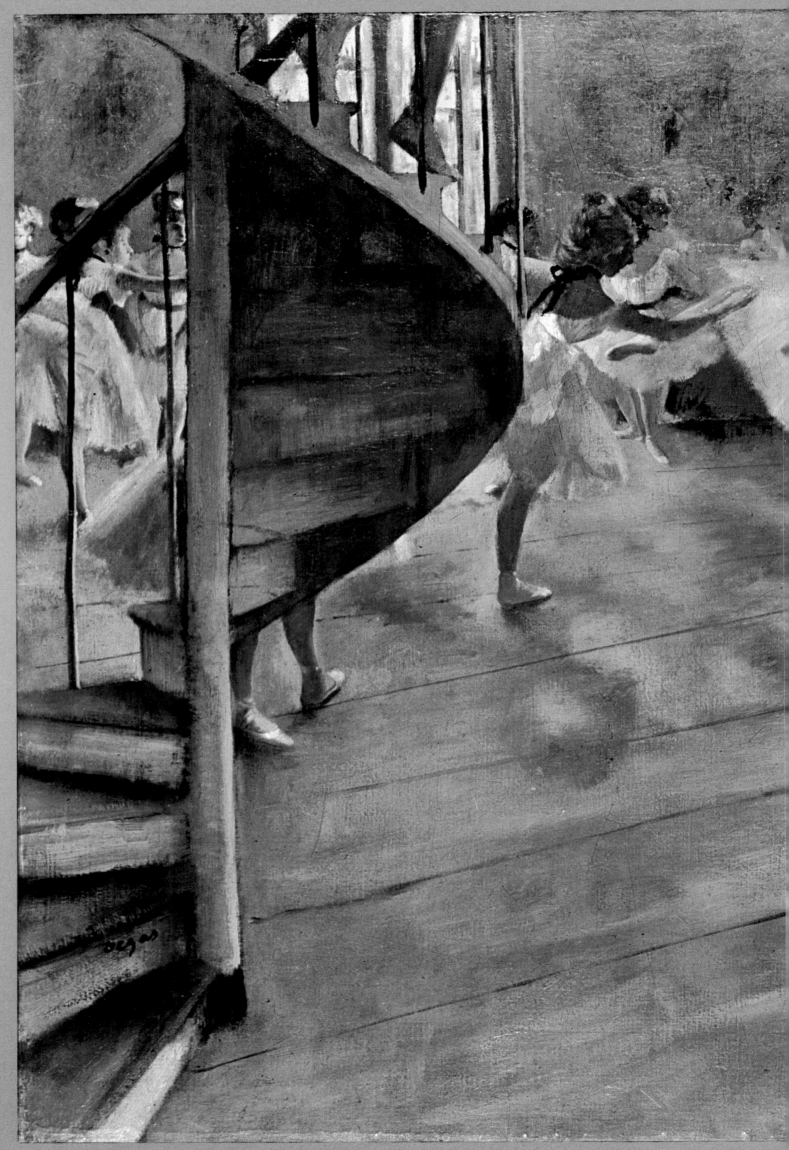

The Rehearsal,
1877. Canvas,
$26^{3}/_{4} \times 40^{1}/_{2}$ in.
Glasgow, Art
Gallery and
Museum, The
Burrell
Collection.

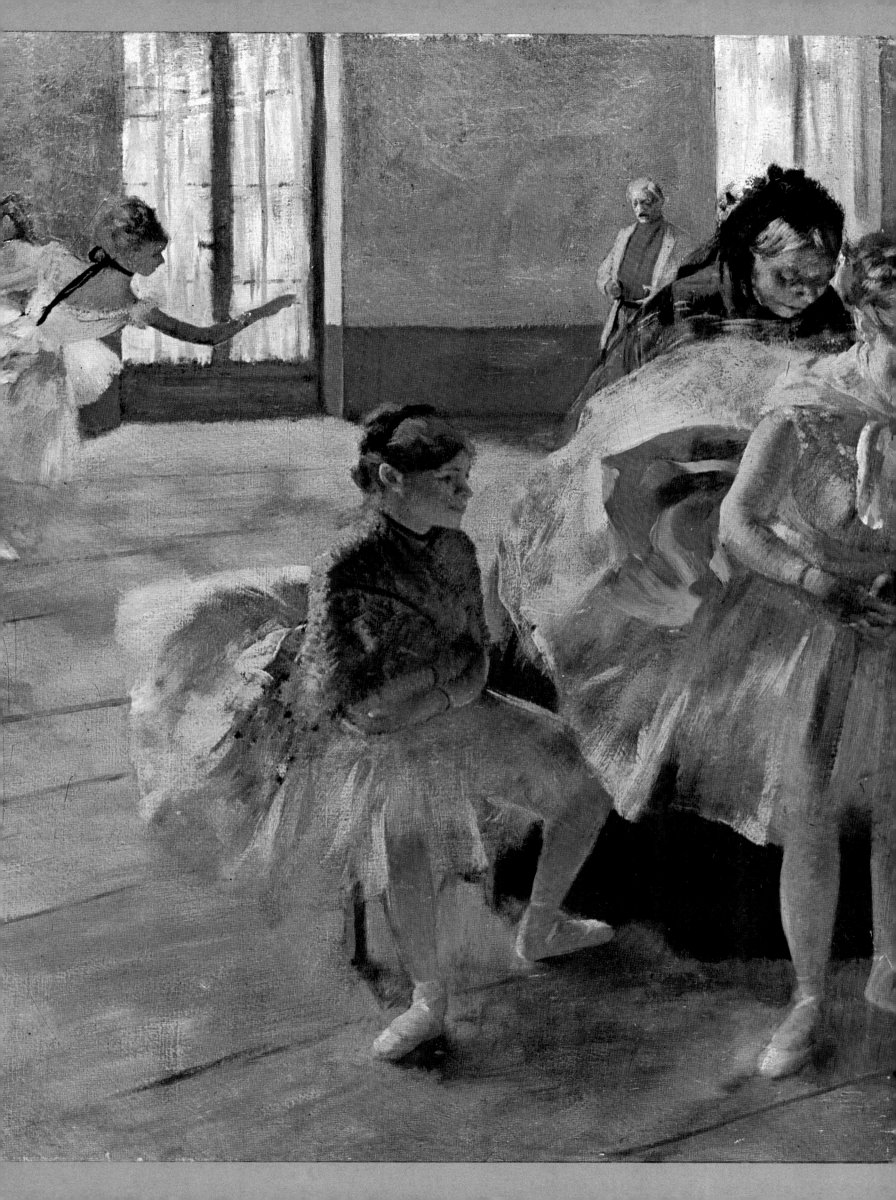

1

2

footlights; the heavily made-up faces and glittering costumes loom up almost weirdly, in sharp contrast with the violin bows, the neck of a cello or double-bass, and the varied headgear of the audience seated in the semidarkness of the foreground. Degas plays up such contrasts with a skill and resourcefulness that make the blacks blacker and his colors brighter. He also exploits the subtler contrasts between lights and their reflections, between "the different tonal values of globe lamps reflected in mirrors." The vivid impression of immediacy is sharpened by the slanting composition of these scenes, a layout based on the diagonals set up by the edge of the stage or the projection of a loge. By his sheer intensity this defender of realism created a dream world of illusion and artifice. "You require natural life," he said to his painter friends, "I require artificial life." The subject in itself

mattered little. What he wanted to record was movement, the transformation and all the subtle momentary revelations of a moving figure. Daumier, whose work was thoroughly familiar to Degas, had already done a series of *Actors*, showing their hallucinatory faces and convulsed expressions in the harsh glare of the footlights. There was another connection between the two artists: the unflattering honesty of the analytical observer which, however generous his nature, makes him a stern and critical judge and, at times, may give his work the force of an indictment.

From 1875 on, Degas was in serious financial straits. His brother Achille had made unwise investments and lost everything. Though he said nothing to anyone, it became a point of honor with Degas to stand by his brother and fulfill his family obligations. (Their father,

1 Dancers at the Bar, study, c. 1876. Oil thinned with turpentine on green paper, 18⁷/₈ × 24³/₄ in.
Private collection. (Photo Archives Photographiques, Paris)

2 Café-Concert, 1876. Pastel, 9¹/₄ × 17 in.
Washington, The Corcoran Gallery of Art, W.A. Clark Collection.

Café Singer (alternate version), 1878. Pastel on gray cardboard, 24³/₄ × 19¹/₄ in. Copenhagen, Ordrupgaard Museum.

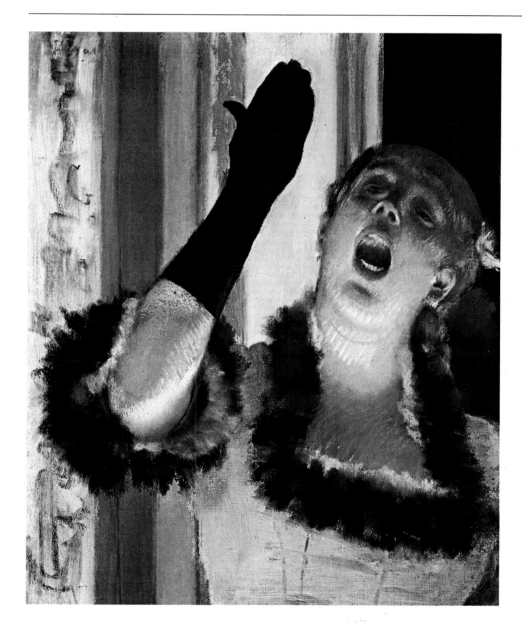

Café Singer, 1878. Pastel, 20⁷/₈ × 16¹/₈ in. Cambridge (Mass.), Courtesy of The Fogg Art Museum, Harvard University, Bequest of Maurice Wertheim.

Pierre-Auguste de Gas, had died in February of 1874.) This meant harder work than ever and longer hours in the studio. Perhaps it was because of these circumstances that he now painted a number of pictures showing strenuous physical effort. The *Washerwomen Carrying Laundry*, a pair of admirable figures performing the same movement in reverse, conveys an impression of intense muscular strain; the lines express a balance of forces, a pattern of tension. Even the color scheme, at once rich and sober in its combination of mauve, umber, and ocher on a gold ground, suggests power and energy.

A new pictorial conception

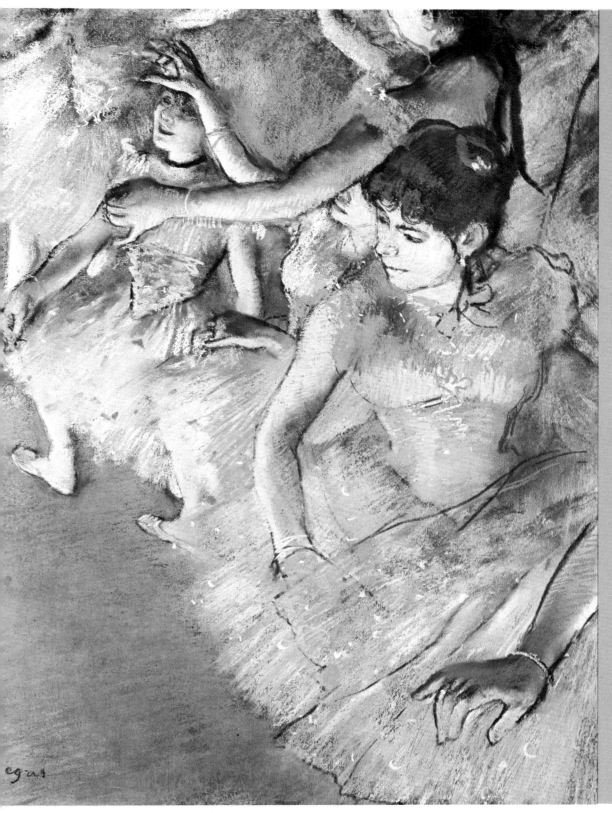

Dancers on Stage, 1883.
Pastel, $24^{3}/_{4} \times 18^{7}/_{8}$ in.
U.S.A., Private collection.

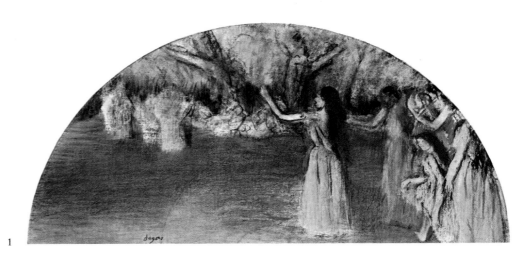

1 **Ballet Scene, c. 1880.**
 Pastel on a fan, 11⁷/₈ × 23¹/₄ in.
 U.S.A., Private collection.

2 **Dancer with a Fan, 1879. Pastel,**
 17³/₄ × 11¹/₂ in. U.S.A., Private collection.

In Degas' passion for work there was an element of self-punishment: he seemed to cultivate difficulty for its own sake, as a challenge to his mettle and resourcefulness. While hard work may be a distraction or refuge, it was never so for him; he was too high-strung, too self-aware and deliberate in his art. "He was one of those men who do not feel they have done or accomplished anything unless they have done it against themselves," wrote Paul Valéry in *Degas,*

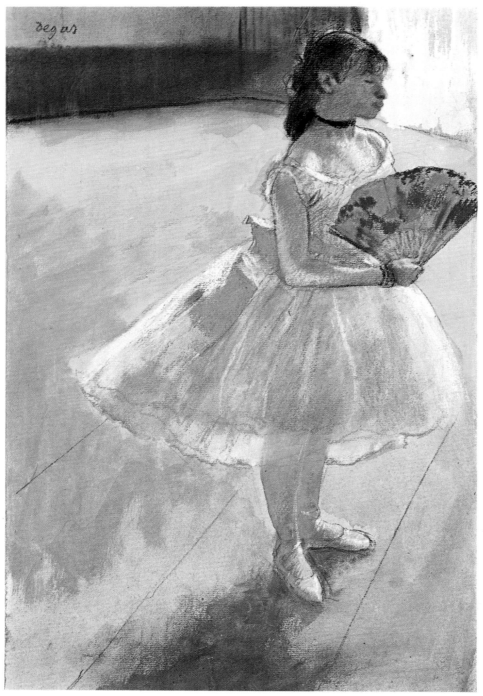

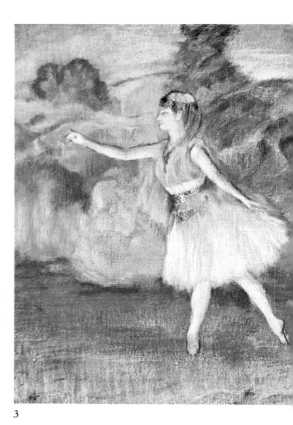

3 **Dancer, c. 1877-80. Pastel,**
 36⁵/₈ × 28³/₄ in. Private collection.
4 **On Stage, c. 1880. Pastel, 22¹/₂ × 16 in.**
 Chicago, Courtesy of The Art Institute
 of Chicago.

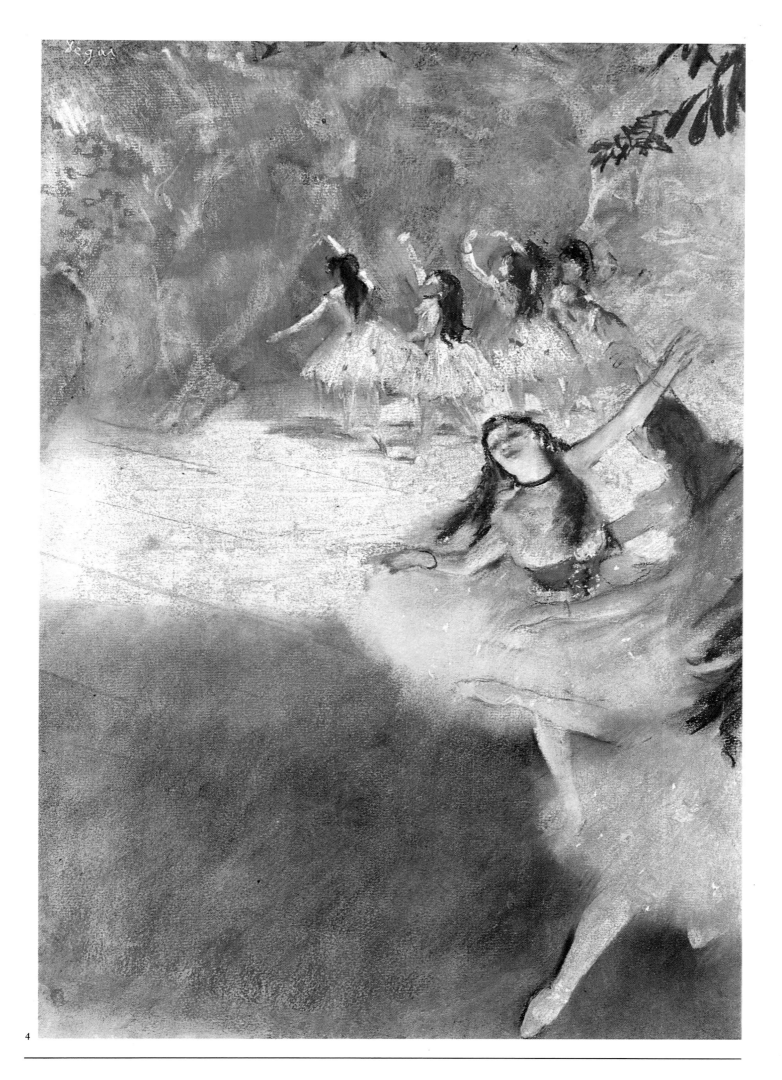

4

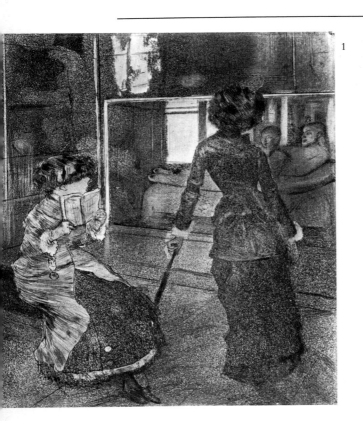

1 **Mary Cassatt at the Louvre (Antiquities Collection), c. 1879-80. Etching, $10^{5/8} \times 9^{3/8}$ in. Paris, Bibliothèque Nationale, Cabinet des Estampes. (Photo Bibliothèque Nationale)**

danse, dessin. Outward personal factors like the obligation to help his brother get back on his feet only strengthened his inner need for discipline and rigorous self-control. But he remained as restless and curious and experimental as ever, always seeking out and perfecting new means of expression.

One of these was his monotypes, drawings in printer's ink on a metal plate. They could be made either by painting with ink on a clean plate (the additive method, or "light-field manner"), or by inking the plate completely and then picking out the design with a brush (the subtractive method or "dark-field manner"). The design was then printed on paper, and to this print colors could be added. Degas contrived to carry the process a step further: by applying this print to another sheet of paper while still wet, he obtained a counter-print, with fainter blacks and grays and more delicate color; also, of course, the design was now in reverse, with symmetrical compositions giving the effect of a mirror image. For a long time he experimented with powdered colors mixed with size, egg yolk, or gouache, with which he could get the mat effect he had seen in Italian fresco painting. In using gouache or watercolor he would boldly add gold or silver highlights, and he applied this technique to painting fans, sometimes working directly on silk. Besides canvas, he also painted on Bristol board and various grades of paper lightly primed with size or oil; on these surfaces he used oil colors thinned with turpentine after the oil had been partly extracted with blotting paper. With pastel, especially, he made endless experiments. He used it in his early work for small portraits and figure studies, then in the 1869 series of beach scenes with varying sky effects. These were pure pastels on a smooth ground, following the method of Delacroix. "Pastel very lightly applied to a somewhat glossy paper is very vibrant. It is a beautiful medium." After 1875 he mixed it with gouache, distemper, or oils thinned with turpentine. He sprayed boiling water over it: depending on the thickness of the pastel, this produced either a paste which he worked with a stiff brush or a wash which he spread with a soft brush. He often applied the two methods to different parts of the same picture. Often, too, he worked over his monotypes with pastel. A few of his monotypes, together with pastels and oils thinned with turpentine, were shown at the third group exhibition of the Impressionists in 1877; his painted fans at the fourth exhibition of "Independents"[1] in 1879; his etchings, including the portrait of *Mary Cassatt at the Louvre*, in 1880.

Degas also practiced sculpture. As a young man he wrote to one of his friends: "I often wonder whether I'll be a painter or a sculptor. I won't deny that I am still befuddled." Before 1870, encouraged by his friend Cuvelier, he modeled a whole series of horse statuettes; many were later reshaped for ex-

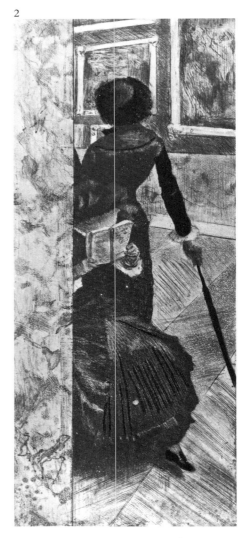

2 **Mary Cassatt at the Louvre (Painting Galleries), c. 1879-80. Etching, $11^{7/8} \times 5$ in. Paris, Bibliothèque Nationale, Cabinet des Estampes. (Photo Bibliothèque Nationale)**

44

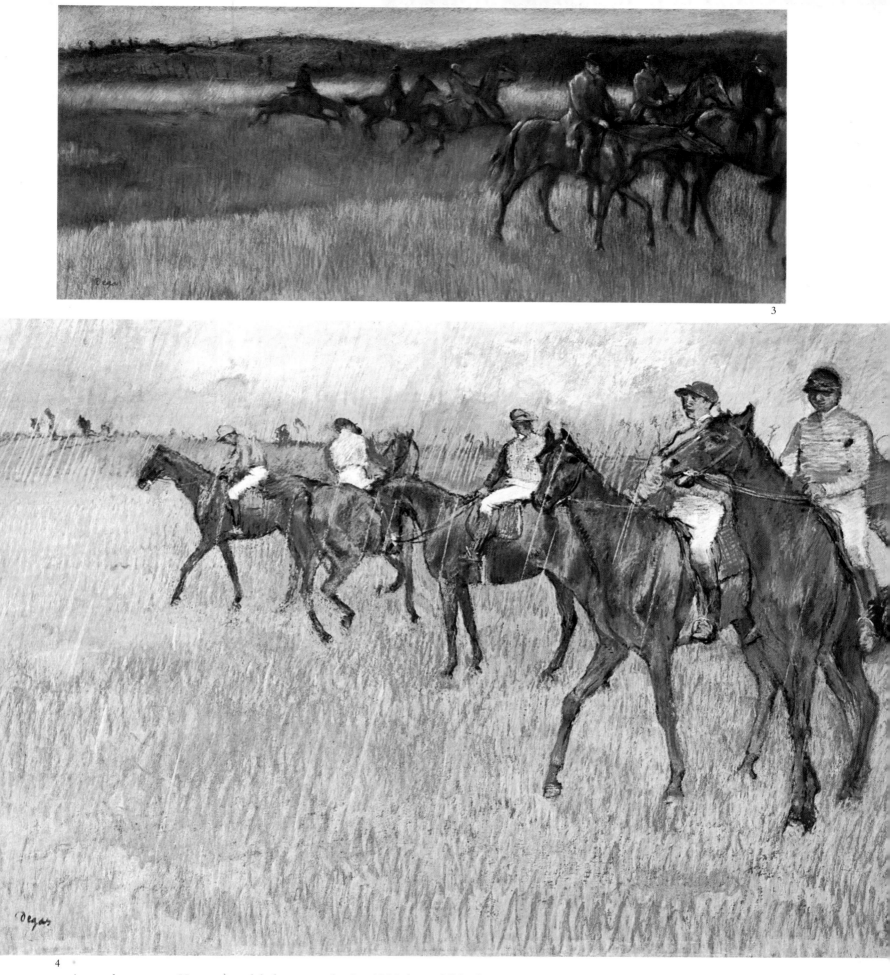

perimental purposes. He next modeled some dancers. These slender figures, which he moved about to catch the light, helped him in the absence of a model to recapture a dancer's gestures, volumes, and proportions. They were not so much a new means of expression as reminders for use in his paintings and pastels. In 1881 he exhibited a wax statuette of a fourteen-year-old dancer; arched and perfectly balanced, the body is tinted and dressed in a bodice of painted canvas and a skirt of real gauze. He depicted dancers in every possible medium, but at no time with any idea of sex appeal. He did not disdain to

3 The Trainers, c. 1880. Pastel, 14⅝ × 34¼ in. U.S.A., Private collection.

4 Jockeys in the Rain, c. 1881. Pastel, 18½ × 25⅝ in. Glasgow, Art Gallery and Museum.

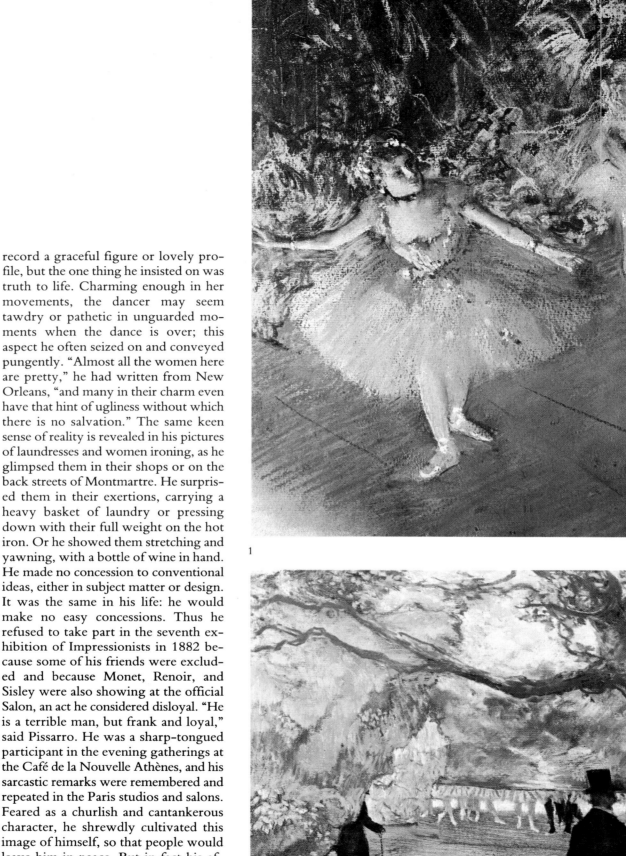

1

2

record a graceful figure or lovely profile, but the one thing he insisted on was truth to life. Charming enough in her movements, the dancer may seem tawdry or pathetic in unguarded moments when the dance is over; this aspect he often seized on and conveyed pungently. "Almost all the women here are pretty," he had written from New Orleans, "and many in their charm even have that hint of ugliness without which there is no salvation." The same keen sense of reality is revealed in his pictures of laundresses and women ironing, as he glimpsed them in their shops or on the back streets of Montmartre. He surprised them in their exertions, carrying a heavy basket of laundry or pressing down with their full weight on the hot iron. Or he showed them stretching and yawning, with a bottle of wine in hand. He made no concession to conventional ideas, either in subject matter or design. It was the same in his life: he would make no easy concessions. Thus he refused to take part in the seventh exhibition of Impressionists in 1882 because some of his friends were excluded and because Monet, Renoir, and Sisley were also showing at the official Salon, an act he considered disloyal. "He is a terrible man, but frank and loyal," said Pissarro. He was a sharp-tongued participant in the evening gatherings at the Café de la Nouvelle Athènes, and his sarcastic remarks were remembered and repeated in the Paris studios and salons. Feared as a churlish and cantankerous character, he shrewdly cultivated this image of himself, so that people would leave him in peace. But in fact his affections and loyalties were strong, and he was capable of fervent enthusiasms and generous self-sacrifice. He cultivated his friends and dined out regularly several times a week, with the Rouarts or with Paul Valpinçon and Ludovic Halévy. He also stayed at their country homes—though never for long, since he was soon bored when away from his studio. "I don't know how to play piquet or billiards, or make small talk,

46

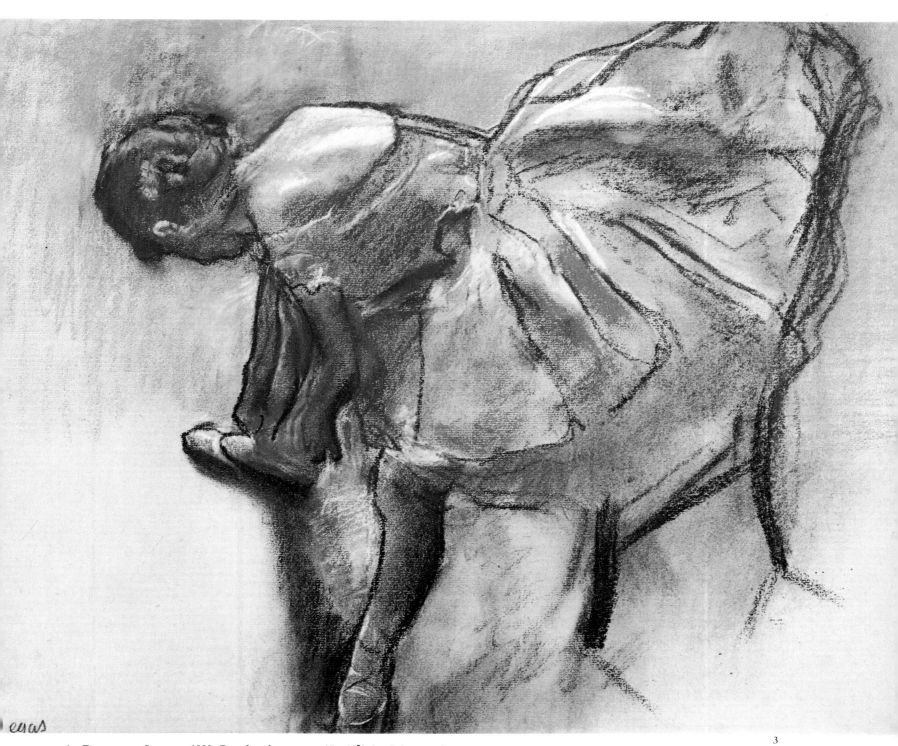

3

1 **Dancers on Stage**, c. 1880. Pastel and tempera, $15 \times 10^5/8$ in. Private collection.

2 **The Curtain**, c. 1881. Pastel, $13^3/4 \times 16^1/8$ in. Collection of Mr. and Mrs. Paul Mellon.

3 **Dancer Tying Her Slipper**, c. 1880. Pastel, $18^1/8 \times 22^7/8$ in. U.S.A., Private collection.

or paint from nature, or simply make myself agreeable to people." His only preoccupation was his work, "the one blessing that may be had for the asking."

Even when he accompanied his lady friends Mary Cassatt or Madame Straus to try on a new hat or a new dress, he was ceaselessly observing the play of their features in the mirror, their hands arranging their hair or setting their hat at the right angle, the milliners hovering around attentively. The feminine love of ornament intrigued him, and we find this entry in one of his notebooks: "Consider an essay on the ornaments worn by women, on their feeling for clothes and other things, their ways of observing and combining them. All day long they compare a thousand visible things that go unnoticed by men."

Manet's death in April 1883 was a grave blow to him. "He was greater than we realized," he told his friends. Relations between them were never easy because their temperaments were so different. Degas was uncompromisingly hostile to the official Salon; Manet, however, took part in it and refused to exhibit with the Impressionists. This and other circumstances created the general belief that they were rivals. Degas was not given to paying compliments and suspected Manet of fishing for them; yet Manet, too, was often unsure of himself—more so than he cared to admit. Degas, nevertheless, was a sincere admirer of his work and proved it by buying many of his pictures. Manet's death was felt deeply by all the Impressionists. It came at a time when both Renoir and Monet were discouraged and dissatisfied with their own work, and Degas was soon to go through a similar crisis.

In 1884, at the age of fifty, he complained in a letter to a friend: "I have made too many plans. Now I am stranded and powerless. I have lost my way. ... I locked up my plans in a closet and always carried the key with me. Now I have

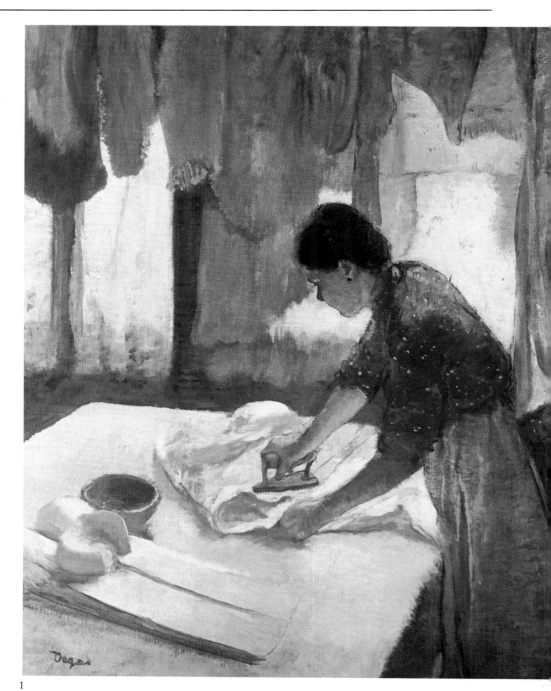

1

1 Laundress Seen in Backlighting, 1882. Oil thinned with turpentine on cardboard primed in pink, 32 × 25⁵/8 in. Collection of Mr. and Mrs. Paul Mellon.

2 Laundresses, c. 1882. Charcoal and pastel, 23¹/4 × 29¹/8 in. U.S.A., Private collection.

3 Laundresses, c. 1884. Canvas, 30 × 32 in. Paris, Musée du Louvre.

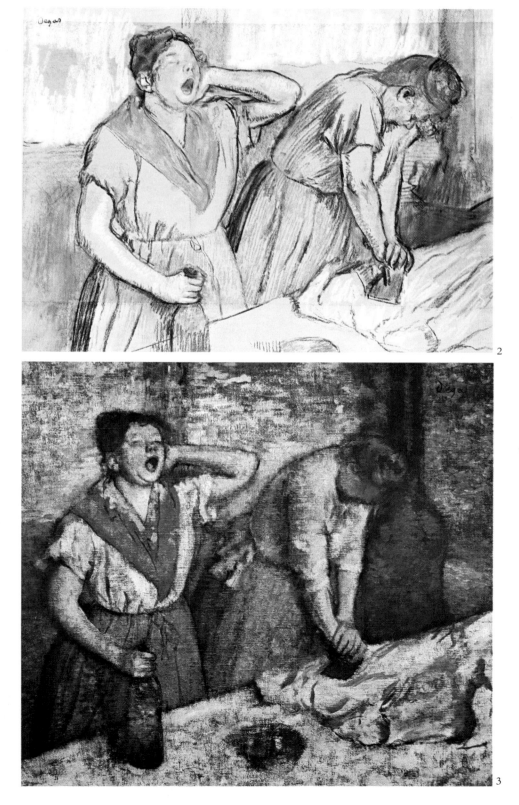

lost that key." But he worked on doggedly and soon recovered his balance. He resumed his experiments with pastel, applying it now in serried, brightly colored hatchings which created a new textural effect, like pouring rain or a shimmering fabric. This concern with color texture drew him momentarily closer to the Impressionists, from whom he differed in so many ways. While they made a cult of painting in the open air, Degas always preferred to work in the peace and seclusion of his studio. "A picture is first of all a product of the artist's imagination; it must never be a copy. The air we see in pictures by the old masters is not the air we breathe." His subjects were also very different from theirs: he painted few landscapes, still lifes, or flower pictures. His handling of color was all his own: from delicate shadings, he moved toward an increasing richness and splendor of effect.

Always varied, the type of composition depended on the medium he employed. In his pastels, we find a sharply viewed, boldly laid out scene, usually in a classic format. In his oils—for example *The Dancing Class, Dancers in the Foyer*—the subject is developed in a pictorial space extending lengthwise. The dancers are spaced out and recede into the distance like Callot's tiny figures, complete in every detail despite their small size. The floor plays a prominent part in these pictures. These broad empty surfaces, with the joints of the floorboards showing, set off vivacious figures of the dancers, the gossamer lightness of their skirts, the poise of their perfectly controlled bodies. In these dancers Degas conveyed what he felt: an intense physical sensation. "I remember Degas saying of a sketch that was submitted to him, 'No, it has no grip'; and to show what he meant, he stamped on the floor with both feet, steadied himself on the boards, and stamped again as if to anchor himself there."[1] Poise, balance, that is the drafts-

1 Jacques-Émile Blanche, *Propos de peintre, de David à Degas*, Paris, 1919.

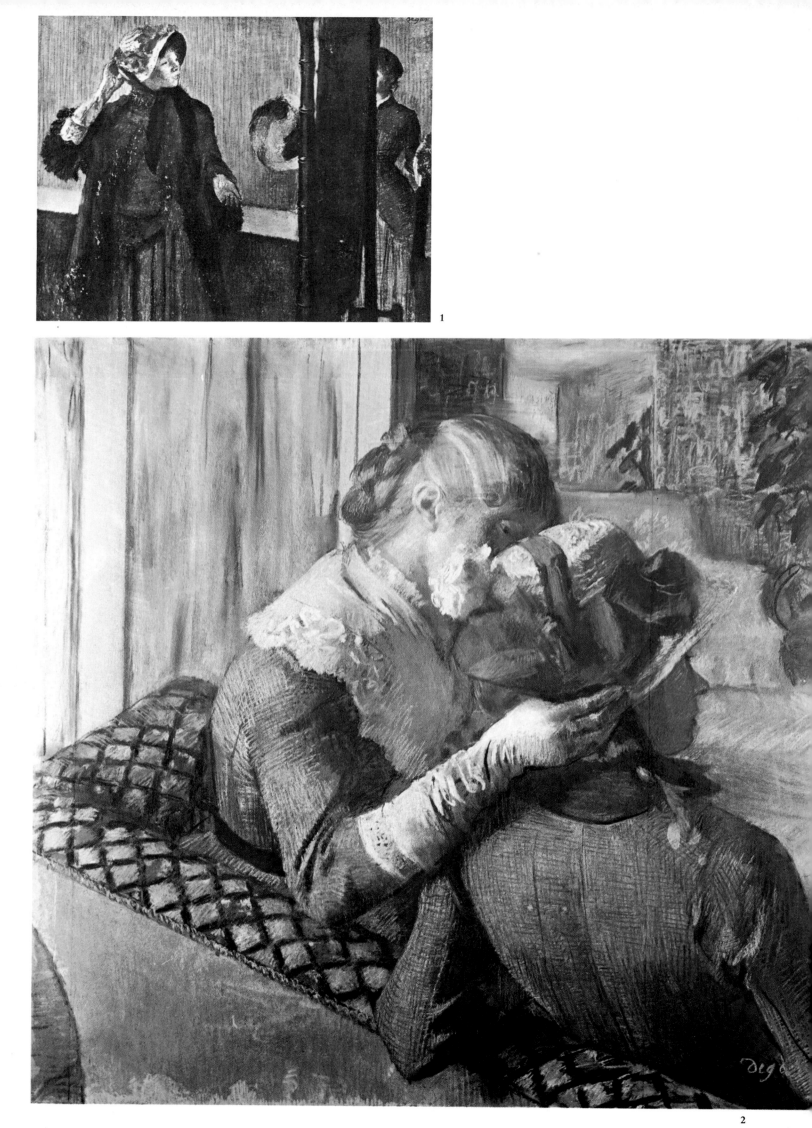

1

2

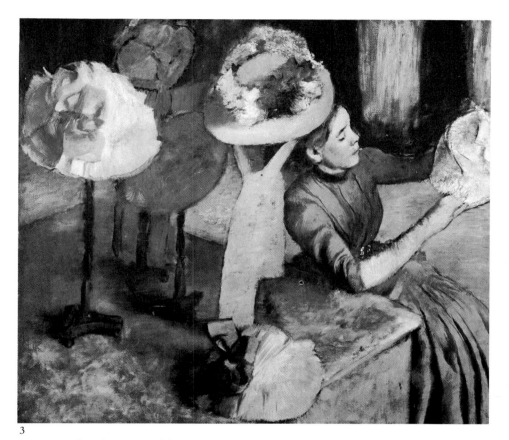

3

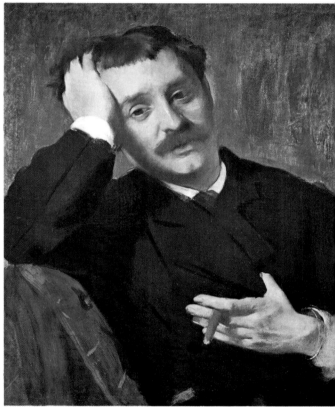

4

man's, and sculptor's problem; without it, the figure fails to hold together. Degas' figures, even the lightest, whether painted or modeled, always have the necessary "weight." This connection with the ground—and even his pirouetting dancers and leaping horses somehow have it—is one of the secrets of his complex art. Firm support gives gestures their energy and assurance; it gives movement its greatest scope. In his statuettes he re-created all the attitudes of dancers, and then all the positions of women at their toilette, bathing, washing, or drying themselves. The first were marked by graceful, outgoing gestures, and their frail adolescent bodies seemed to reflect fresh, budding powers and ideal aspirations; the second group was shown with compact, inward gestures, the full-bodied forms of mature women caught in the most prosaic tasks. Degas reveled in such contrasts. From the classical vision of his early nudes, those he had drawn in Italy and painted in his historical scenes,

1 **At the Milliner's (Miss Cassatt), 1882. Pastel, 29¹/₂ × 33¹/₂ in.
New York, The Metropolitan Museum of Art, Bequest of Mrs. H.O. Havemeyer, 1929.**

2 **At the Milliner's (Woman Trying on a Hat), 1885. Pastel, 27¹/₂ × 27¹/₂ in.
U.S.A., Private collection.**

3 **At the Milliner's, 1885. Canvas, 39 × 43 in.
Chicago, Courtesy of The Art Institute of Chicago.**

4 **Portrait of Lorenzo Pagans, or The Man with a Cigar, 1882. Canvas, 23¹/₄ × 19¹/₄ in.
U.S.A., Private collection.**

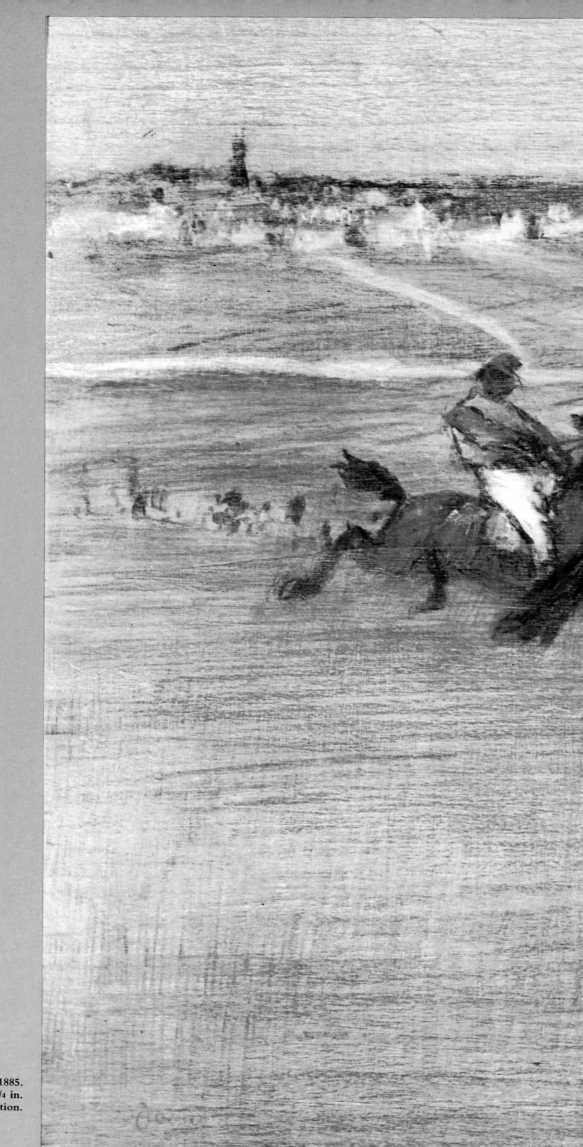

Racehorses, c. 1885.
Pastel, 12⁵/8 × 15³/4 in.
Private collection.

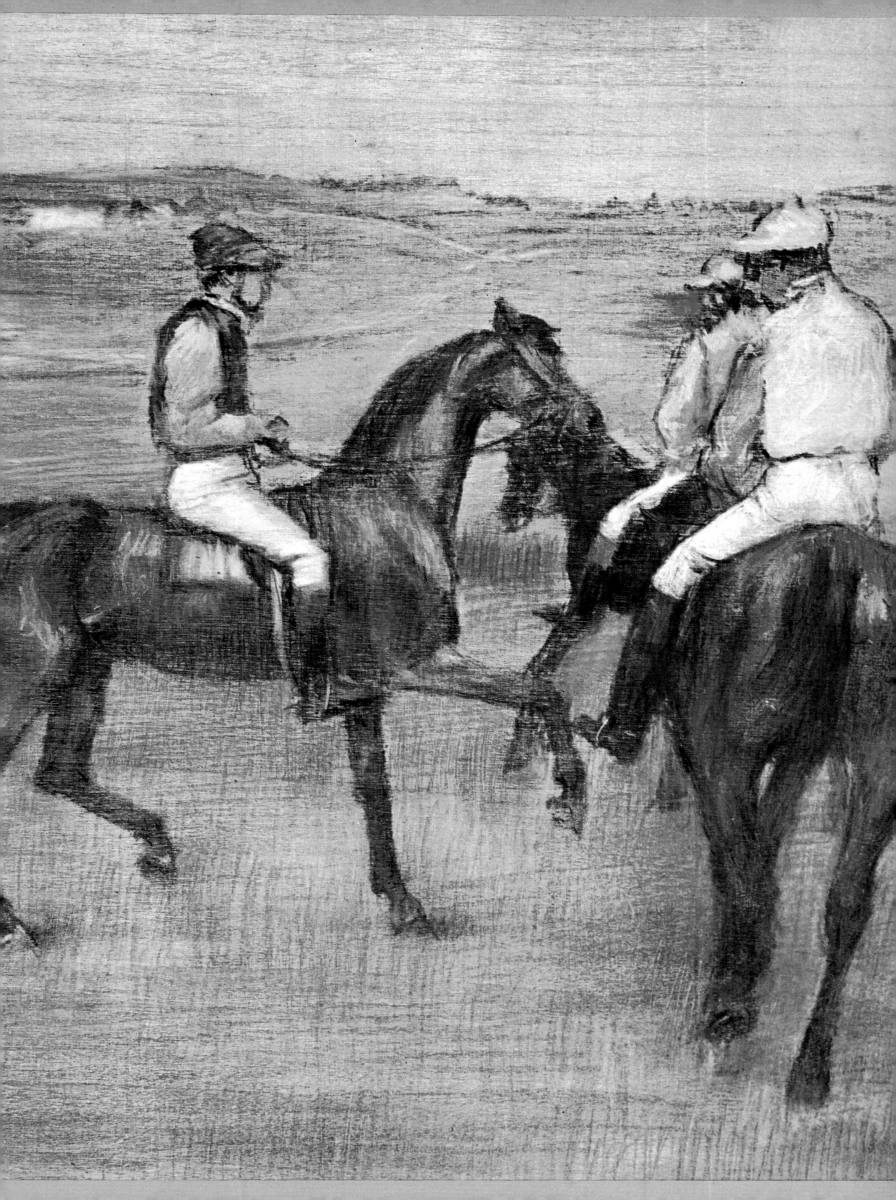

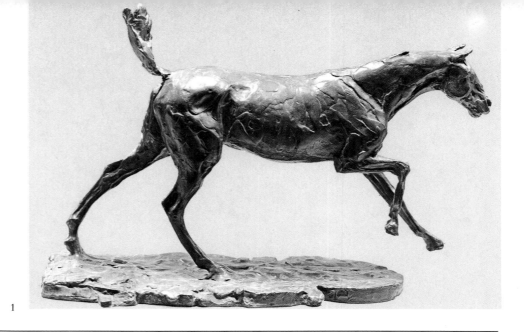

1

he thus moved on to a wholly modern vision of bodies in strenuous action, and sometimes unappealing poses. Comparing these new works to earlier forms of art, Renoir said of Degas' statuettes: "Since Chartres, I see only one sculptor, and that is Degas. The cathedral sculptors succeeded in giving the idea of eternity. That was the great preoccupation of their time. Degas manages to express the disease our contemporaries are suffering from. I mean movement. We can't stand still, and Degas' horses and figures do move. The Chinese were about the only ones before him who discovered the secret of movement. That's the greatness of Degas: movement in a French style."

In 1886, at the eighth and last Impressionist exhibition, Degas exhibited a series of pastels representing "nudes of women bathing, washing, drying, wiping themselves, combing their hair or having it combed." Here the model was observed without any regard for the conventions of academic art, without any facile aim to please. The painter's sole concern was to render his impression of a body wholly occupied with itself, caught from odd angles in unexpected foreshortenings. This resulted in apparent distortions and disproportions. Critics shook their heads, speaking of cynicism, cruelty, and misogyny. Truly, no artist had ever shown such single-mindedness in painting the body for its own sake, with no idea of pleasing the eye or senses. "This is the human animal cleaning itself, a cat licking itself," he said. But it is one-sided and unjust to see only the distortions and the "hint of ugliness," for the attitudes of some of these women at their toilette are very beautiful. Transcending the notion of realism or naturalism, Degas moved toward a new pictorial conception in which form, movement, and color all became one, an organic and unified whole. "A picture is an original combination of lines and tones that set each other off."

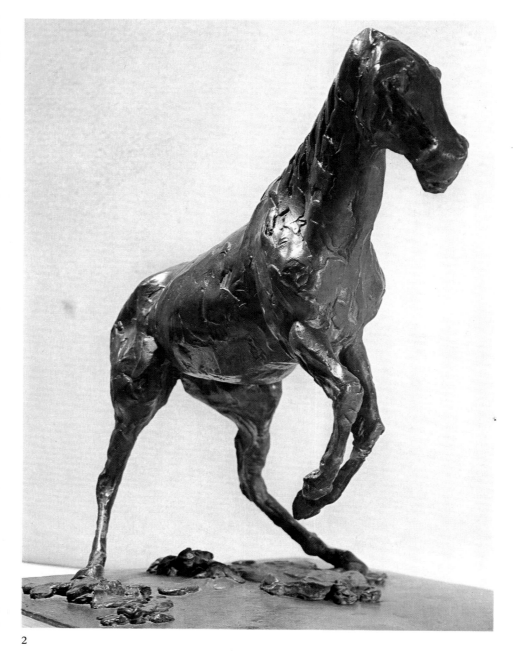

2

1 **Galloping Horse, c. 1879-80. Bronze, height 16¹/8 in.
 Geneva, Private collection.**

2 **Horse Rearing before an Obstacle, c. 1879-80. Bronze, height 12¹/4 in.
 Paris, Musée du Louvre.**

3 **Jockeys before the Race, c. 1885. Canvas, 28³/4 × 35⁷/8 in.**

54

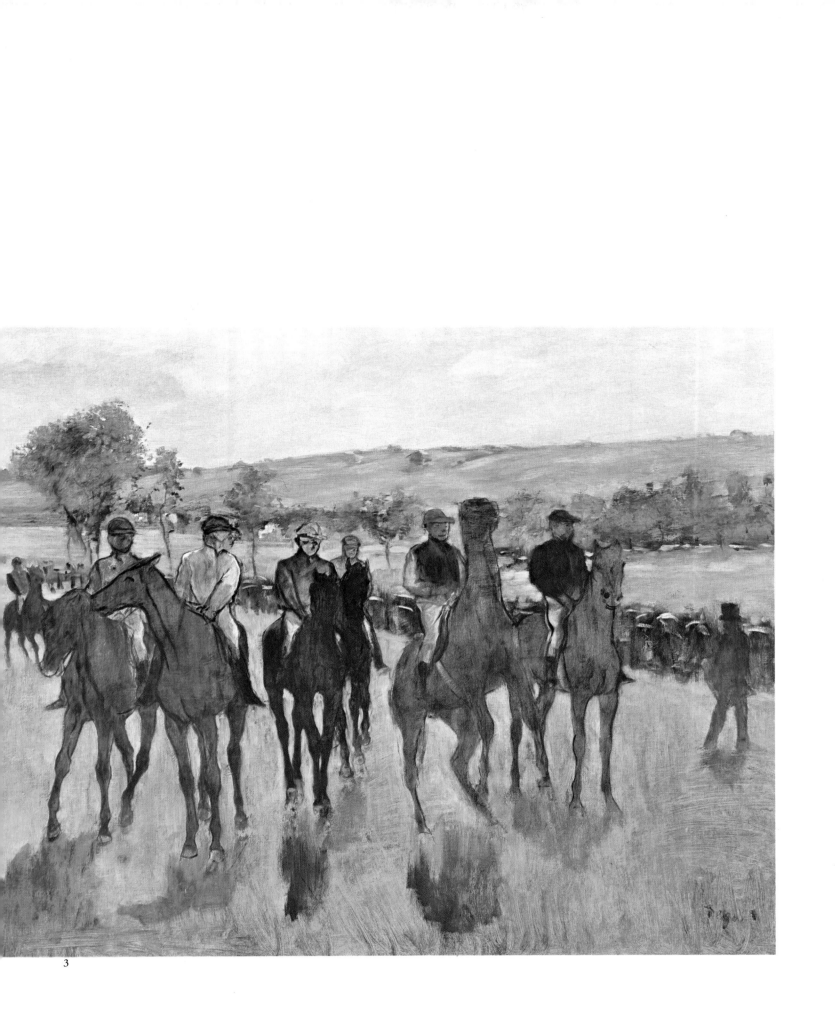

3

Dancers "from another planet"

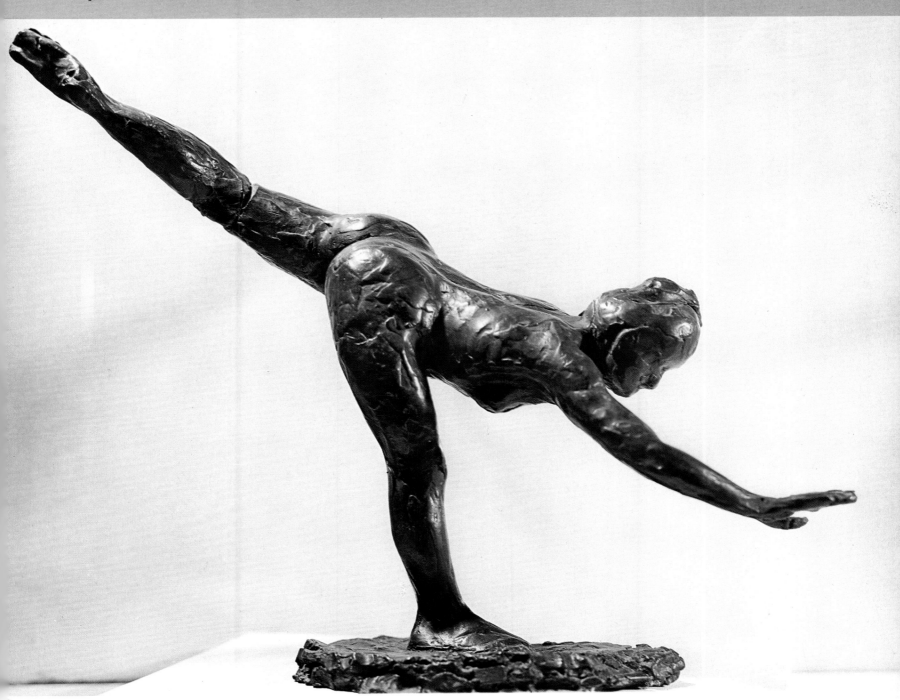

Grand Arabesque: Third Position, 1882-95. Bronze, height 16$\frac{1}{2}$ in. Paris, Musée du Louvre.

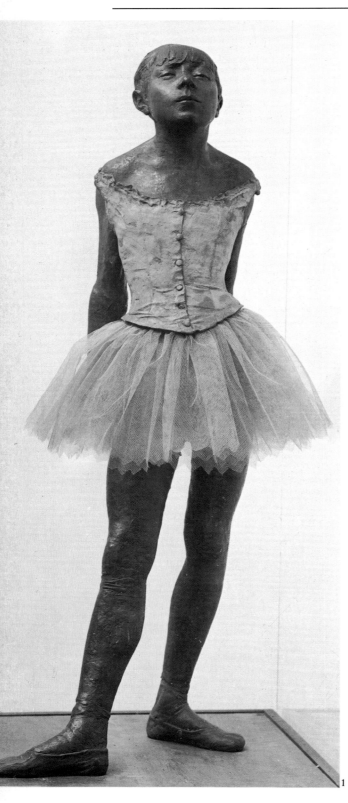

The "fierce" Degas—that "terrible" man, as Berthe Morisot and Pissarro described him—was indeed one of those "difficult and incorruptible characters" later spoken of by Paul Valéry. When his contemporaries referred to him, they said "Monsieur Degas" (as an earlier generation had said "Monsieur Ingres"), as much out of a feeling of awe as of heart that yearned to express itself. Degas was never at a loss for the telling remark—sarcastic, cutting, ironical, or sly—that summed up a person or a situation. His quips often reveal the art student's love of a good joke, and they were taken up and repeated in all the Paris studios. "They shoot us, but they go through our pockets," he said of the

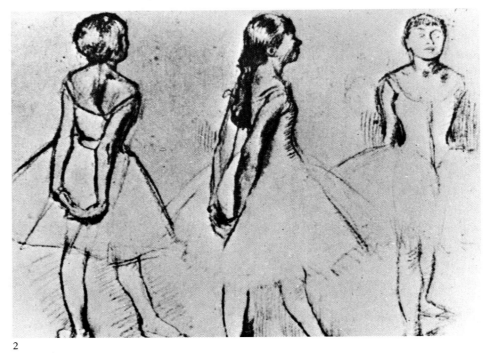

2

respect. He was a loner by nature; his work and temperament required solitude, yet at the same time he suffered from it. In being aggressive, sarcastic, and frequently unjust in his comments, he was asserting his independence and underlying bitterness, for he was always divided within himself. To Alexis Rouart he once said, "I should like to be famous and unknown." If he seemed the very embodiment of paradox and contradiction, it was because he kept his mind working at peak capacity and was too exacting with himself always to be concerned with or to spare others. He lashed out at them because he was so vulnerable himself; his apparent harshness masked a tender

painters who, while criticizing the Impressionists, proceeded to imitate them. Meissonier, a slick academic who painted small, minutely detailed pictures, was "as tiny as his painting." Renoir was "a cat playing with balls of wool." Before Gustave Moreau's canvases, in which all the figures are loaded with jewels and finery, his comment was: "Even the elephants flaunt their watch fobs." Thinking of Pissarro's pure landscapes, he said of an idyllic picture by Bastien-Lepage showing a mooning young couple in a field: "They are making love while Pissarro is away." On a day in the country: "The weather is fine, but more like Monet than my poor eyes can bear." These were a painter's re-

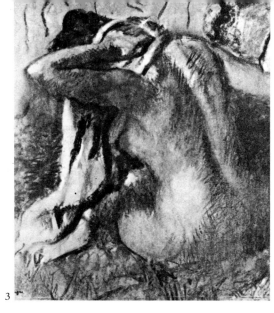

3

5 After the Bath, or Woman Drying Herself, study, c. 1884. Pastel and charcoal, $13 \times 19^{5/8}$ in. Private collection. (Photo Routhier)

6 Woman Drying Her Hair, 1885. Pastel, $25^{1/4} \times 19^{5/8}$ in. U.S.A., Private collection.

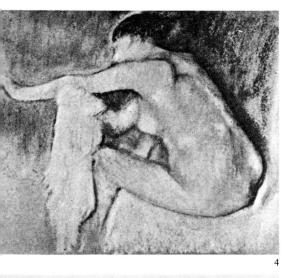

4

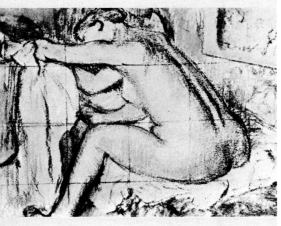

5

1 Fourteen-year-old Dancer, 1880–81. Bronze, height $38^{1/2}$ in. Paris, Musée du Louvre.

2 Studies for "Fourteen-year-old Dancer," 1880–81. Charcoal and pastel, $18^{1/8} \times 24$ in. Private collection.

3 Study for "Woman Drying Her Hair," 1885. Pastel, $30^{1/4} \times 22^{1/2}$ in. Private collection. (Photo Routhier)

4 Study for "Woman Drying Herself," 1884. Pastel. Private collection. (Photo Routhier)

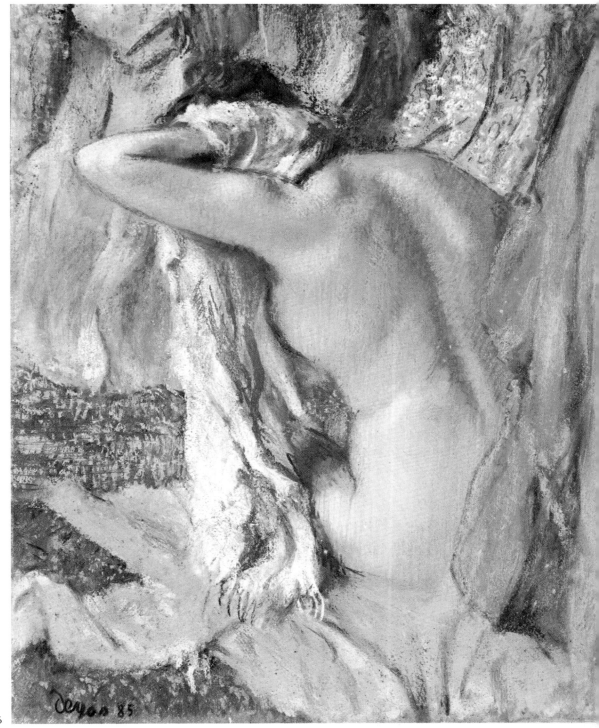

6

marks, in which imagery plays its part. On the opening day of an exhibition, noticing the simplicity of Madame Renoir among a crowd of overdressed ladies, he said to Renoir: "Your wife looks like a queen visiting a circus sideshow." He described Corot, whom he admired, as "an angel who smokes a pipe." At times his remarks reflect the concerns of the craftsman. To a friend who quoted Amiel's aphorism "A landscape is a state of mind," he replied, "No, a landscape is a state of eyes" — thus insisting on the specific, often prosaic problems that confront the painter. At the Opera he reproached a well-to-do man about town who had run off with a dancer he and Forain had employed as a model: "My dear sir, you have no right to take our tools away from us!"

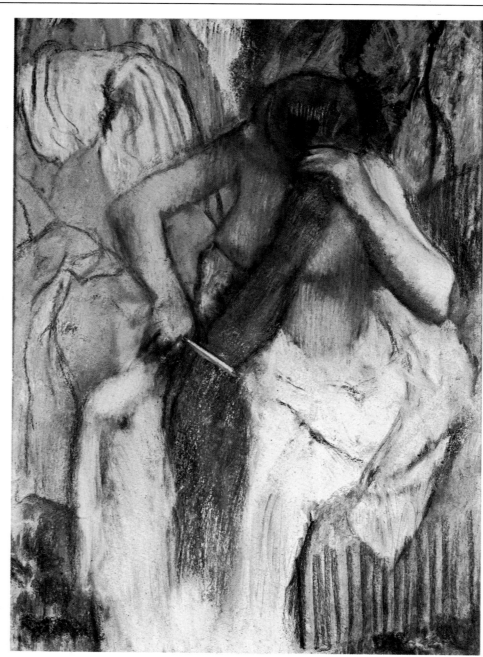

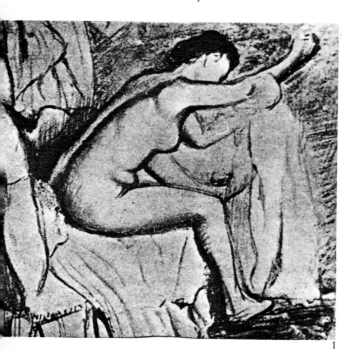

This emphasis on the practical side of his art is re-echoed in his many aphorisms on painting and drawing, and in certain admissions more explicit than any commentary on the links between the man and the artist. "It is essential to keep on looking at everything, the little boats

1 **Woman Drying Her Arm, study, c. 1884. Pastel, 22 × 26³/8 in. Private collection.**

2 **Woman Combing Her Hair, 1887-90. Pastel, 32¹/4 × 22¹/2 in. Paris, Musée du Louvre. (Photo Josse)**

3 **Woman Wiping Her Feet, 1886. Pastel, 21³/8 × 20⁵/8 in. Paris, Musée du Louvre.**

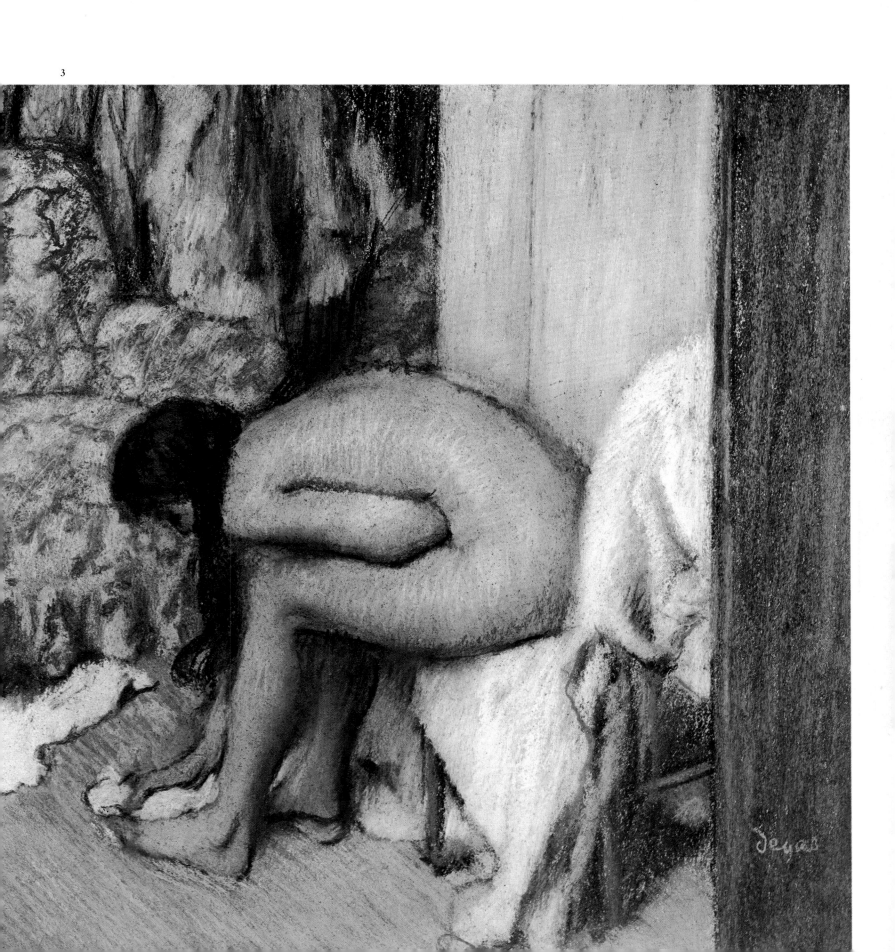

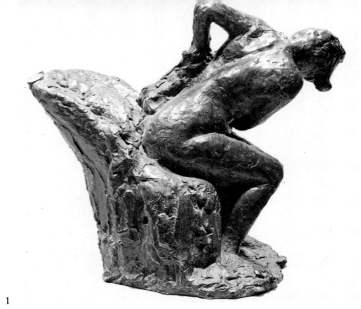

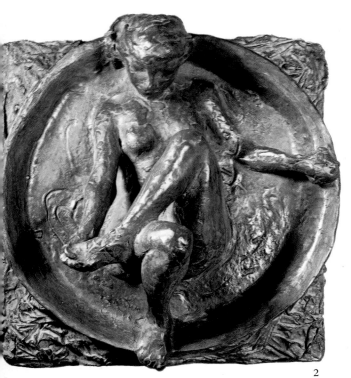

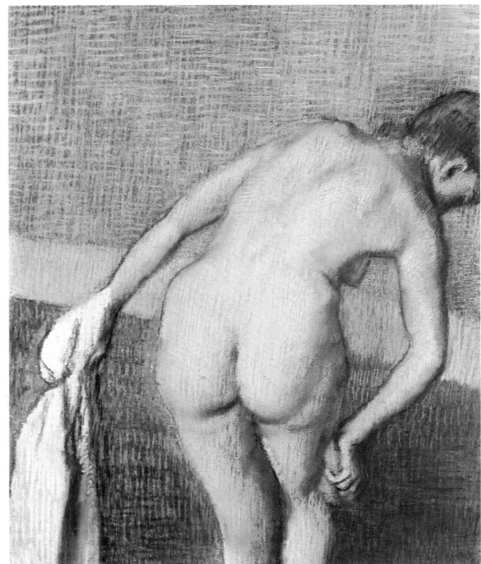

and the big ships, the stir of people on the water and on land as well. What diverts and consoles us is the movement of things and people. If the leaves on the trees did not move, how sad the trees would be — and we too!" Degas himself was a man possessed by that "love of bustle" which, as an art student in Italy, he had noted in Signorelli. The forms of his art, especially in his later years, reveal a passion for movement, a restless mind bent on seizing not the instant but the succession of instants. He was intent on conveying the impression of life in its endless modifications and transformations, capturing the energy it emits, the forces it puts into play, and the resulting welter of forms and colors and changing lights.

Knowing only too well that a picture cannot expect to convey life itself but can only give the illusion of it by living a life of its own, by being "an original combination of lines and tones that set each other off," he insisted on the essential role of willpower in this transfor-

1 Seated Woman Wiping Her Left Hip, 1896-1911. Bronze, height 17^1/$_2$ in. Geneva, Private collection.

2 The Tub, c. 1886. Bronze, 18^1/$_2$ × 16^1/$_2$ in. Bern, Collection of Dr. Jacques Koerfer.

3 Woman Washing Herself in a Tub, c. 1886. Pastel, 28^3/$_8$ × 22 in. U.S.A., Private collection.

4 After the Bath, or Woman Wiping Her Neck, 1898. Pastel on cardboard, 24^3/$_8$ × 25^5/$_8$ in. Paris, Musée du Louvre, Cabinet des Dessins.

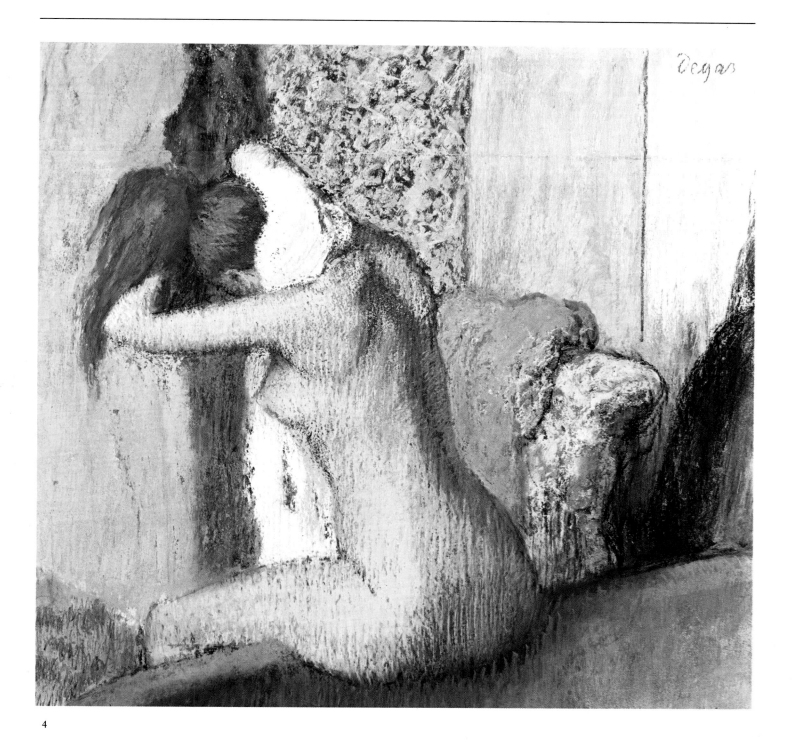

4

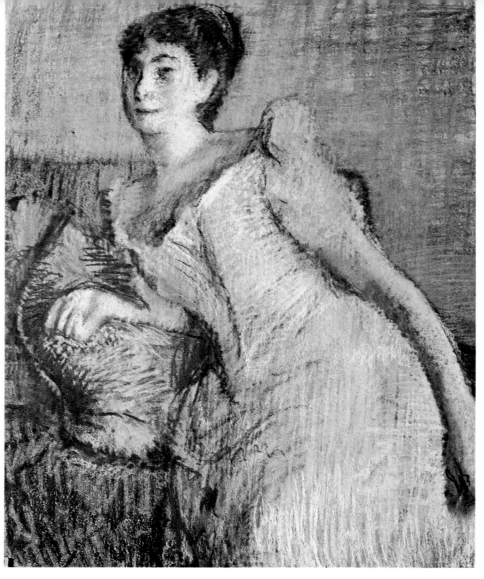

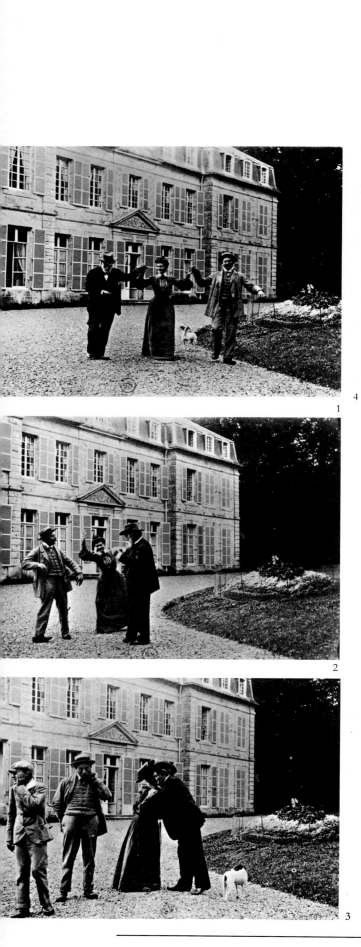

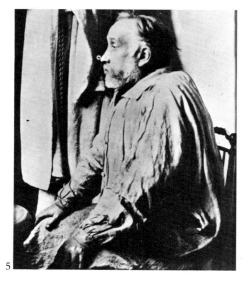

1, 2, 3 Photographs of Degas (in dark suit) miming a dance with his friends M. and Mme. Fourchy before the Château de Ménil-Hubert (Normandy), about 1903. (Photo Bibliothèque Nationale)

4 Portrait of a Seated Woman, 1892-95. Pastel, 28 × 23¼ in. Paris, Private collection.

mation of reality into painting. "One sees what one wants to see, and this falsehood constitutes art." "What we have to do is cast a spell on Truth and give it the appearance of Madness." Such an aim may seem contradictory, but it is not surprising in an artist accustomed to confronting one extreme with another. Moreover, it is not so very different from the concern expressed by Ingres when he said: "In matters of truth, it is better to go a little beyond it, no matter what the risk." Degas worked on as hard as ever in his studio. "The same subject must be done again and again, ten times, a hundred times. Nothing in art should seem accidental, not even movement." Early in 1889 some of his latest pastels, of women at their toilette and dancers, were exhibited at the Galerie Boussod-Valadon. Mallarmé called them "marvels."[1]

Odilon Redon noted in his diary: "What skill in the studied, deliberate handling of juxtaposed, highpitched tones, used to such arresting effect!"

In September 1889 Degas went on a short trip to Spain and Morocco with the painter Boldini. In the fall, traveling from Paris with the sculptor Bartholomé in a gig drawn by a white horse, he paid a visit to his friend Jean-

1 In a letter of February 17, 1889, to Berthe Morisot, in which he also refers to Degas' sonnets: "For relaxation he writes poetry, and the great event of this winter is that he has reached his fourth sonnet — a new art form in which, I must say, he is doing some very pretty things."

5 Degas in his studio in Rue Victor Massé, photograph taken by Bartholomé before 1912. (Photo Bibliothèque Nationale)

6 Portrait of Alexis Rouart, 1895. Pastel, 22 × 15³/4 in. U.S.A., Private collection.

6

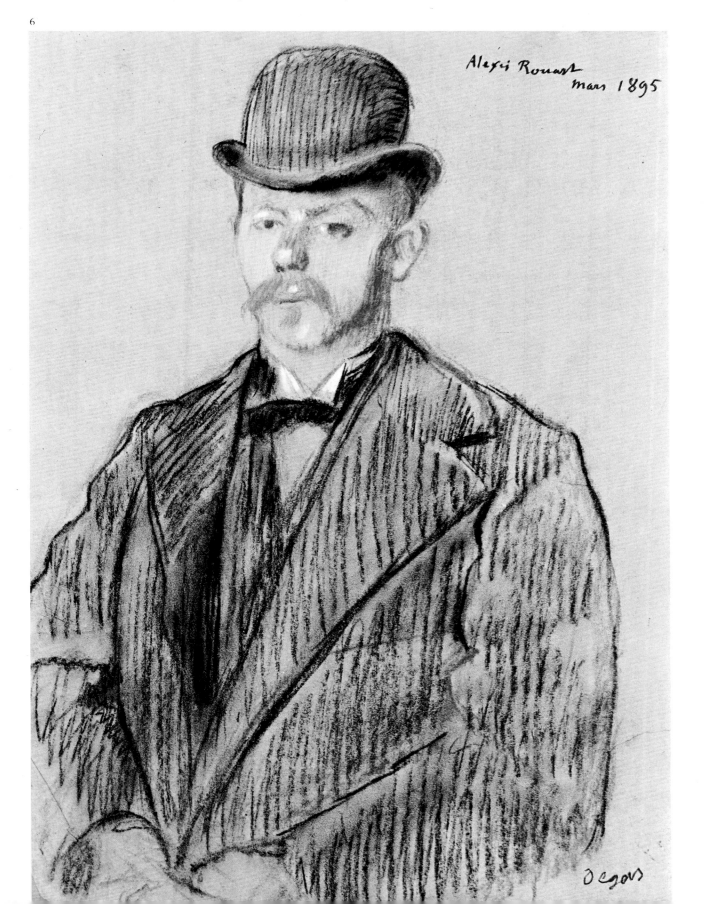

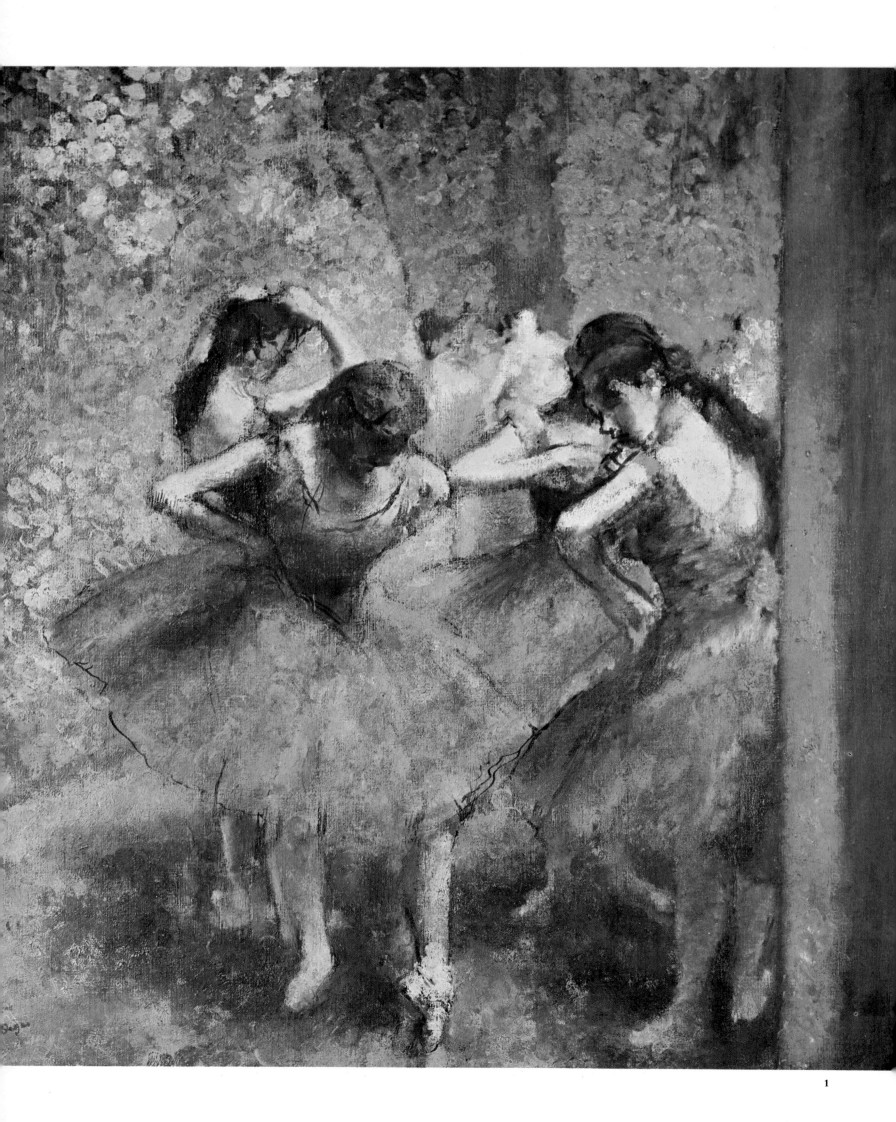

1 Dancers in Blue, 1890. Pastel, 33¹/₂ × 29¹/₂ in. Paris, Musée du Louvre.

2 Dancer with a Red Shawl, c. 1889. Pastel, 25¹/₈ × 19³/₈ in.
 U.S.A., Private collection.

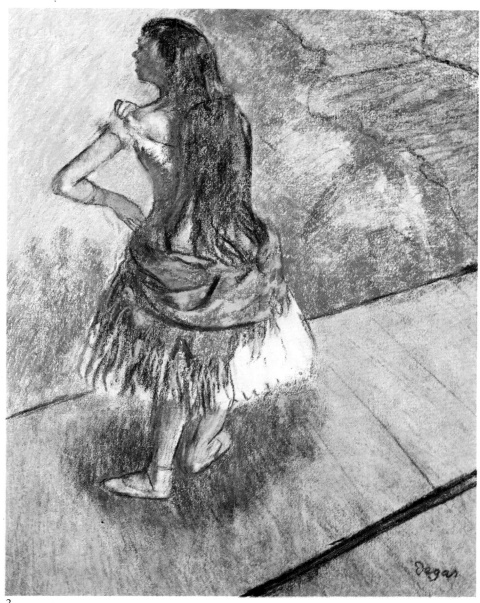

2

que, Degas was led now to apply the colors in successive layers; each layer being coated with a fixative before being covered by the next. In this way he tried to recreate the transparent glazing of the Venetian masters, allowing the undercoat to show through here and there. This procedure, combined with hatchings, gave a new richness and glow to his colors. In his oils he reverted to an old technique: applying the colors with his finger, he spread them with the flat of his hand, going over the outlines with a brush. Some were in subdued, closely related tones, almost monochrome, but others were in bright contrasting colors which, applied with the thumb, took on a texture resembling that of fabrics, like the effect he had achieved with hatchings in his pastels. In fact, the walls of his studio were hung with tapestries, and he had always had a sensitive eye for the texture of handkerchiefs, rugs, and different kinds of materials. Once he had even urged the publisher Charpentier to illustrate an edition of Zola's *Bonheur des Dames*, a novel centering on a dry-goods store, "with samples of textiles and passementerie."

Nudes at their toilette and dancers were the themes on which he experimented with these new combinations of color used with unparalleled freedom. "Degas is exhibiting some outright marvels at Durand-Ruel's," wrote Paul Valéry to André Gide in March 1898. "Dancers, yes — but dancers from some other, extraordinary planet." The "subject" per se lost its importance. That apparent "indifference" to the subject, which Georges Bataille has also commented on in Manet, was now seen in Degas. He painted women without dwelling on their femininity, since as an artist his overriding concern was with movement, lines of force, and the magic of color. "They call me the painter of dancers; they don't realize that for me the dancer is a pretext for painting pretty materials and rendering movements."

niot at Diénay in Burgundy. At Diénay, working from memory, he recorded some of the landscapes seen on the way in a series of monotypes heightened with pastel. Some of these were included in a one-man show held in October 1892. He referred to them himself as "fantasies and dreams," for the visionary imagination entered into them at least as much as memory. "I'm holding a

small exhibition at Durand-Ruel's of twenty-six imaginary landscapes, and reactions have been quite favorable." This was his only one-man show during his lifetime. He would exhibit his pictures only when compelled to sell something. "Painting belongs to one's private life. One works only for a very few."

Still seeking to perfect his pastel techni-

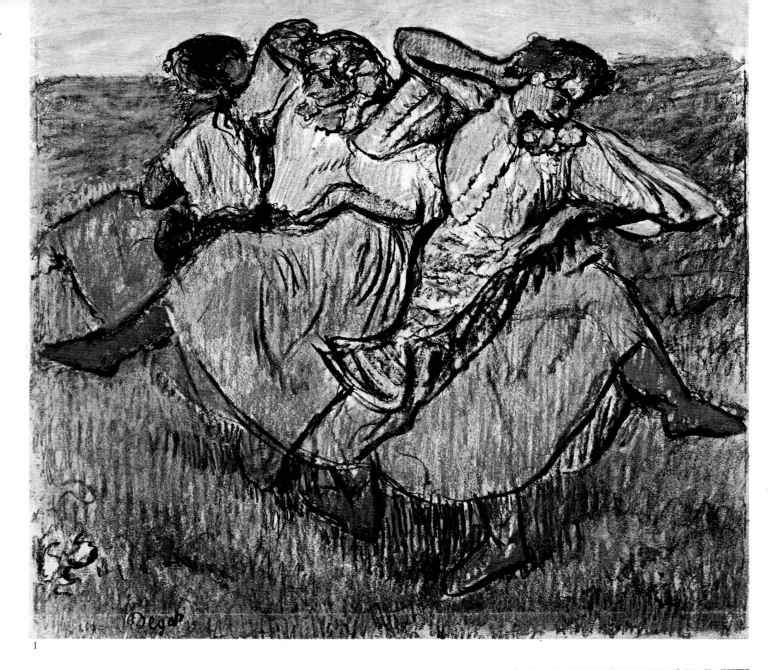

"Drawing is not form; it is a way of seeing form." "Even in front of nature one must compose." By such observations, Degas meant that the artist is compelled to change what he sees, to make something *different*: that is the distinctive mark of the true creator and his freedom. This conception of painting sets him apart from most of the Impressionists, who kept more closely to nature. For this reason the younger painters such as Lautrec, Bonnard, Vuillard, and Maurice Denis particularly admired Degas, and he followed their work with interest and regularly attended their exhibitions. Suzanne Valadon, who had met him through Lautrec and Bartholomé, described him in the early 1900's: "At seventy Degas was still very handsome. He had the brow of Verlaine, a fine mouth, and his agate eyes were full of irony."

Paul Valéry had met Degas ten years before, about 1893-1894, at the Rouarts'. "I had fancied what he was like from some of his works I had seen and some of his witticisms that people repeated. A short time before, I had written 'An Evening with Monsieur Teste,'

and this little attempt at an imaginary portrait, though based on remarks and accounts I had checked as carefully as possible, was to some extent influenced (so to speak) by a *certain Degas that I pictured to myself*. Ideas of various monsters of intelligence and self-awareness often haunted me at that time." Leonardo da Vinci, Mallarmé, Degas — the attraction of such minds for Valéry reveals much about his own mind. He was the same type of man, with the same love of rigorous thinking and the operations of the intellect, "which makes a problem of everything." He too tended toward "scaffolding" of thought (outlines, projects, sketches) and was interested in the "mechanics" of the mind, the "mind in action." Valéry and Degas in particular shared the same belief in the challenging stimulus of difficulty: "A difficulty is a light. An insurmountable difficulty is a sun." Their lives were marked by the same solitude, by their "habitual conviction as to the peculiar nature of self." The same pessimism: "Every man contains something terribly dark and prodigiously bitter." The same pleasure in creating

1 Russian Dancers, c. 1895. Pastel, 24³/₄ × 26 in. Stockholm, Nationalmuseum.

2 Three Dancers in Blue, c. 1898. Pastel sketch, 28³/₈ × 15³/₈ in. Private collection.

3 Three Dancers in Violet Tutus, 1898. Pastel, 28³/₄ × 19 in.

4 Spanish Dance, 1882-95. Bronze, height 17 in. Paris, Musée du Louvre.

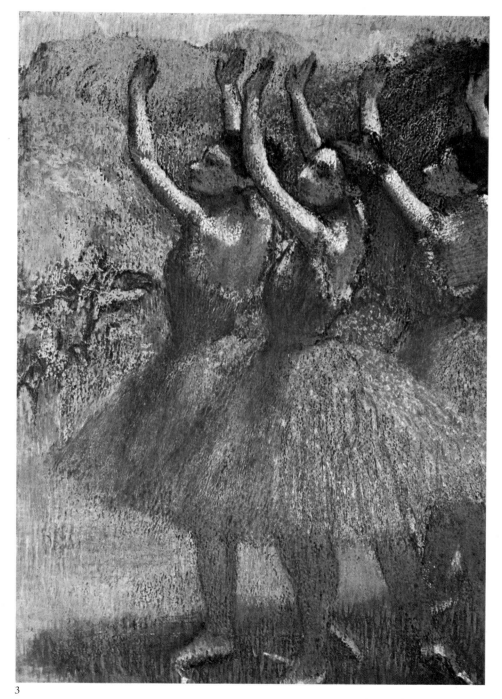

something, "a strange, complex pleasure fraught with torment and drudgery." The same faith in doing rather than achieving: "The act means more than the result." In a word, they had the same taste for experiment. "I have spent my whole life experimenting," said Degas. But the experiments of both often attain a perfection that neither expected to achieve. For Paul Valéry, then, Degas represented a model of what the mind could be and could do; at the same time, he was an endorsement and example of what Valéry meant by "mind." Valéry was profoundly influenced by his en-

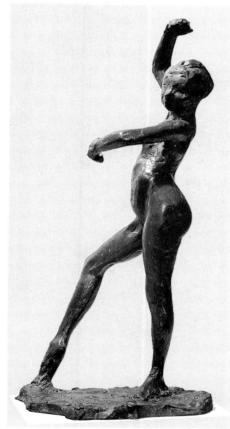

3

4

1 Three Dancers, c. 1900. Pastel, 29^{1}/$_{8}$ × 23^{5}/$_{8}$ in. U.S.A., Private collection.

2 Photograph of Degas taken by Bartholomé in his garden at Auteuil in 1915. Paris,
 Bibliothèque Nationale, Cabinet des Estampes. (Photo Bibliothèque Nationale)

3 Photograph of Degas walking in the streets of Paris about 1914, from Sacha Guitry's
 film "Ceux de chez nous." (Photo Bibliothèque Nationale)

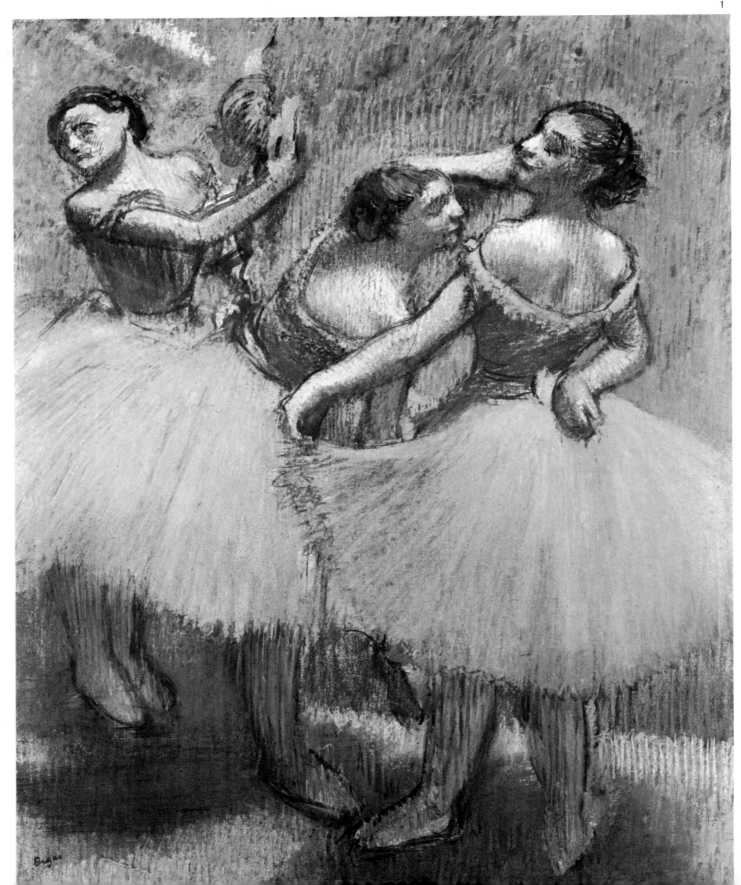

counter with Degas, who in so many ways served to confirm his own aspirations and convictions.

At that time, in the 1890's and early 1900's, Degas lived in Montmartre at 37 Rue Victor Massé, in a threestory house, with his apartment on one floor and his studio above. Valéry has described that

2

3

attic studio, a long room under the eaves "with a large window (of unwashed panes) where light and dust played happily." To this sanctum, where the artist pursued his alchemy, only a few intimate friends were ever admitted. "An element of mystery is necessary, there must be a certain aura of mystery around an artist's work. Are people allowed into a chemist's laboratory?" he said to Daniel Halévy. In spite of eye trouble, Degas carried on, composing some large charcoal drawings which he built up with successive tracings around the previous outlines. In his late pastels he achieved color harmonies even more lavish and glowing than before. His last nudes were painted sculptures; in the masterly build-up of volumes and what Pissarro called the "vital sensation," they possess the ideal beauty of ancient classical nudes and the realism of Gothic

statuary, while their colors herald a new world.

These were the final efforts of an artist whose failing eyesight had grown steadily worse through the years. Toward the end Degas was nearly blind, and painting was now out of the question; only sculpture remained to him. He became more gruff and temperamental than ever. At the time of the Dreyfus case he broke with his old friend Ludovic Halévy, though he always remained on affectionate terms with his son Daniel Halévy. He had already fallen out with the Irish writer George Moore, who dared to publish some reminiscences of him and praised him (as he thought) too highly. His friends Alexis and Henri Rouart died in 1911 and 1912, respectively. In 1912, too, he had to leave his old home in Rue Victor Massé, when the building was

torn down. Stacking up his art collection and his own works in a new apartment in Boulevard de Clichy, he stopped working and spent his days walking the streets or taking long streetcar trips into outlying districts. Daniel Halévy remembered him as he was then, "in his Inverness cape, always thrusting out his cane to feel his way. Yet he walked fast, always alone." Up to 1915 he still visited his friend Bartholomé in Rue Raffet. After that he hardly left his apartment any more. "The heavy lids," wrote Jacques-Émile Blanche, "close over those eyes which were previously so keen and which now, for too long, can only distinguish objects one part at a time." Edgar Degas died in Paris on September 27, 1917, at the age of eighty-three. "Ah, Degas," said Forain, "how fine he was at the end, walking through the streets."

Documentation

Degas year by year

Since Degas continually reworked his pictures and reverted again and again to the same themes (he worked for several years on *The Bellelli Family* and spent nearly five years on his large history pictures), it is difficult to find a really characteristic work for each year of his career. Furthermore, after 1905, because of failing eyesight, he practically gave up painting and turned to sculpture.

c. 1859
Giovannina and
Giulia Bellelli.
Canvas,
30 × 23⁵/8 in.
Rome, Private coll.

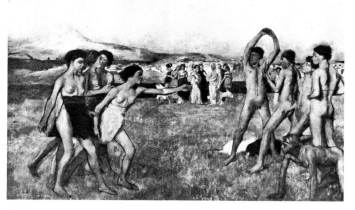

1860 Spartan Girls and Boys Exercising. Canvas, 43 × 61 in. London, National Gallery, Reproduced by courtesy of the Trustees.

c. 1863 Portrait of Léon Bonnat. Canvas, 17 × 14¹/8 in. Bayonne, Musée Bonnat. (Photo Giraudon)

1857 Portrait of René-Hilaire de Gas, the Artist's Grandfather. Canvas, 21⁵/8 × 16¹/8 in. Paris, Musée du Louvre. (Photo Giraudon)

1858-60 Reclining Female Nude. Canvas, 20¹/2 × 24¹/2 in. Wuppertal, Von der Heydt Museum. (Photo Giraudon)

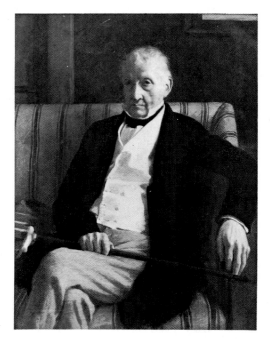

c. 1865 Manet Listening to His Wife Play the Piano.
Canvas, 25⁵/₈ × 28 in. Osaka, K. Wada Collection.

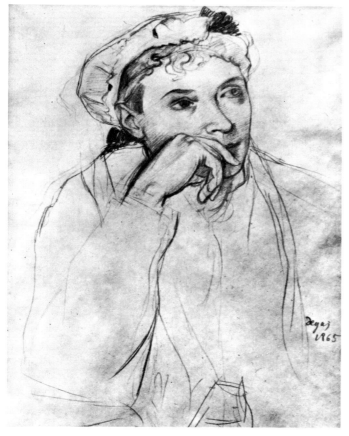

1865 Study for Portrait of Madame Hertel. Pencil drawing,
12¹/₄ × 9⁷/₈ in. Cambridge (Mass.), Courtesy of The Fogg Art
Museum, Harvard University. (Photo Giraudon)

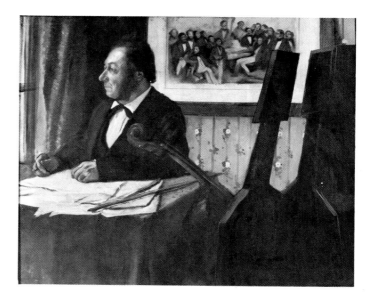

1868-69 The Cellist Pillet. Canvas, 19 × 23⁵/₈ in.
Paris, Musée du Louvre. (Photo Giraudon)

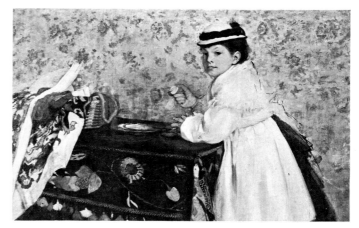

1869 Portrait of Hortense Valpinçon. Canvas, 28³/₄ × 43¹/₄ in.
Minneapolis, The Minneapolis Institute of Arts.

1868-72 Copy of Mantegna's "Crucifixion." Canv., 26³/₈ × 36¹/₄ in.
Tours, Musée des Beaux-Arts. (Photo Giraudon)

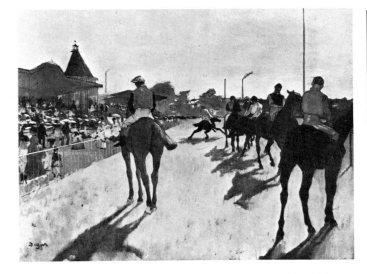

c. 1869-72 Jockeys before the Grandstands. Canvas, 18¹/₈ × 24 in.
Paris, Musée du Louvre.

1869-72 Degas' Father Listening to the Singer Pagans. Canvas,
32 × 25¹/₂ in. Boston, Courtesy of Museum of Fine Arts,
Bequest of John T. Spaulding. (Photo Giraudon)

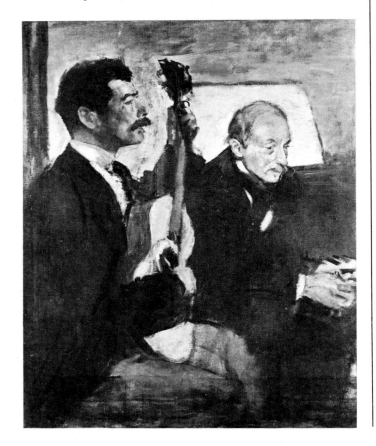

1872 Woman with a Vase of Flowers. Canvas,
29¹/₂ × 21¹/₄ in.
Paris, Musée du Louvre. (Photo Giraudon)

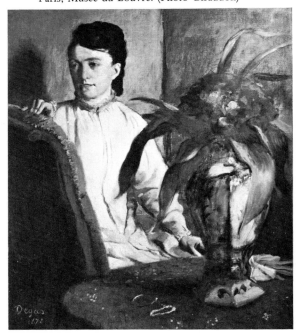

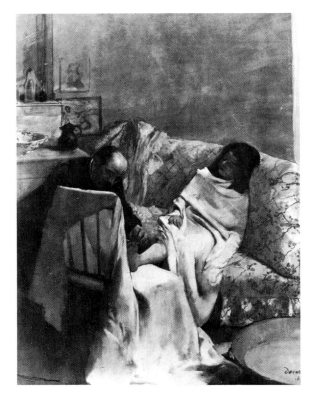

1873 The Pedicure. Canvas, 24 × 18¹/₈ in.
Paris, Musée du Louvre. (Photo Giraudon)

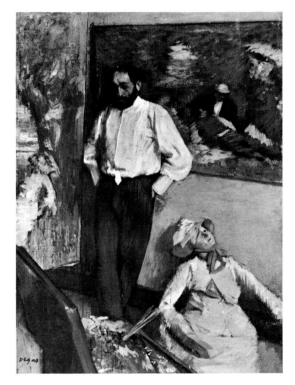

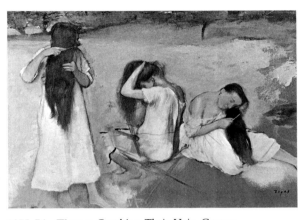

1875-76 Women Combing Their Hair. Canvas, 12$^{1}/_{4}$ × 17$^{3}/_{4}$ in. Washington, The Phillips Collection.

c. 1873 Man with a Puppet. Canvas, 16$^{1}/_{8}$ × 10$^{5}/_{8}$ in. Lisbon, Gulbenkian Museum. (Photo Giraudon)

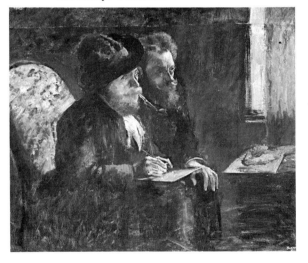

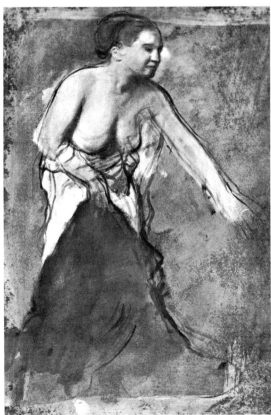

c. 1874 Half-naked Woman. Canvas, 24 × 19$^{3}/_{4}$ in. Basel, Rudolf Staechelin Collection. (Photo Giraudon)

c. 1876 Marcellin Desboutin and Vicomte Lepic. Canvas, 28$^{3}/_{8}$ × 32 in. Nice, Musée des Beaux-Arts.

1876-77 Carlo Pellegrini. Watercolor and pastel, 24 × 13 in. London, Tate Gallery, Reproduced by courtesy of the Trustees.

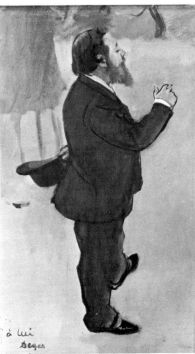

77

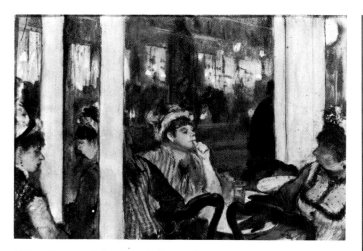

1877 Women sitting in a Café. Pastel over monotype. 16¹/₈ × 23⁵/₈ in. Paris, Musée du Louvre. (Photo Giraudon)

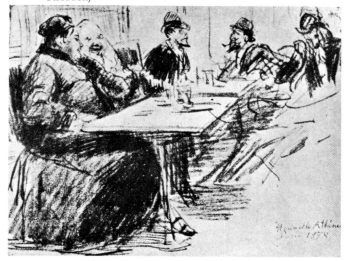

1878
Café de la Nouvelle Athènes. Drawing. Paris, Exsteens Collection.

1879
Portrait of Edmond Duranty. Pastel, 39³/₈ × 39³/₈ in. Glasgow, Art Gallery and Museum, The Burrell Collection.

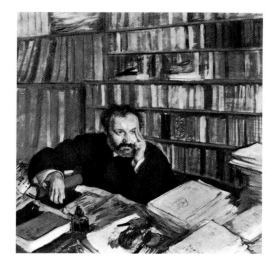

1879-80 Mary Cassatt at the Louvre. Pastel, 23⁵/₈ × 18¹/₂ in. Philadelphia, Henry P. McIlhenny Collection.

1880-85 Rearing Horse. Bronze, height 13 in. Paris, Musée du Louvre.

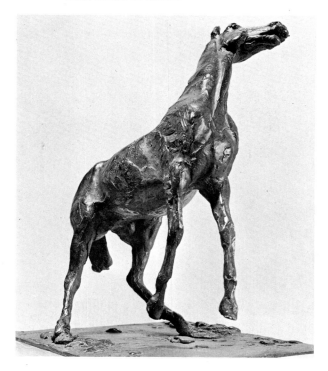

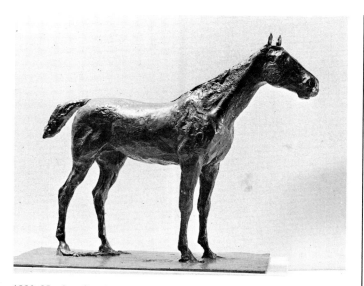

1880-85 Standing Horse. Bronze, h. 11¹/₂ in. Paris, Musée du Louvre.

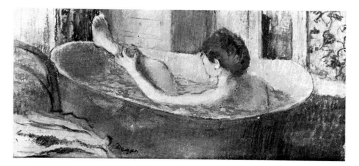

c. 1883
Woman
Bathing.
Pastel over
monotype,
7¹/₂ × 16¹/₈ in.
Paris, Musée
du Louvre

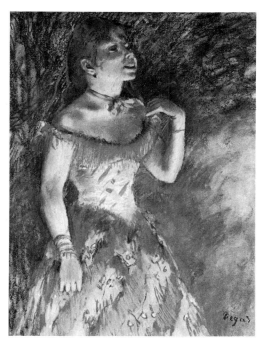

1884
The Singer in
Green. Pastel,
23³/₄ × 18¹/₄
in.
New York,
The
Metropolitan
Museum of
Art. Bequest
of Stephen C.
Clark, 1960.

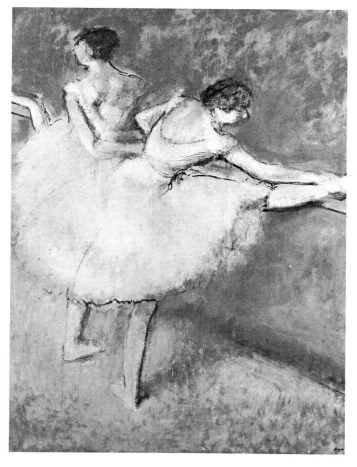

1884-88
Dancers at the Bar.
Oil thinned with
turpentine on canvas,
51 × 38 in.
Washington, The
Phillips Collection.

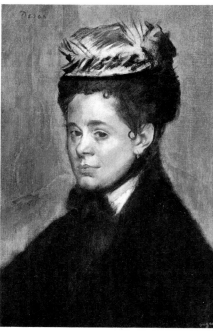

1887-90
Bust of a Woman.
Canvas, 21⁵/₈ × 14¹/₈
in. Private
collection.

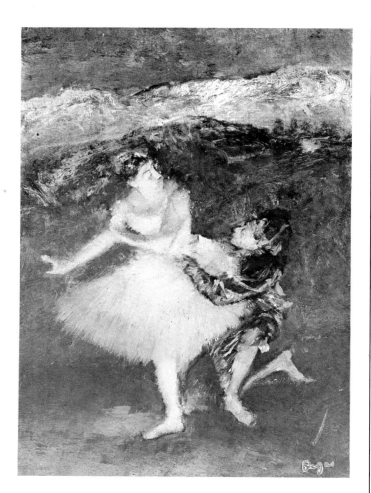

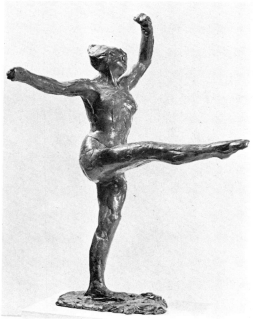

c. 1891-95
Harlequin
and
Columbine.
Oil on
wood,
13 × 9 in.
Paris, Musée
du Louvre.

1890-98
Dancer in
Fourth
Position.
Brown wax,
height 16
in. Paris,
Musée du
Louvre.

1890-98 Dancer Looking at the Sole of Her Right Foot.
Wax, height 18$^{1}/_{8}$ in. Paris, Musée du Louvre.

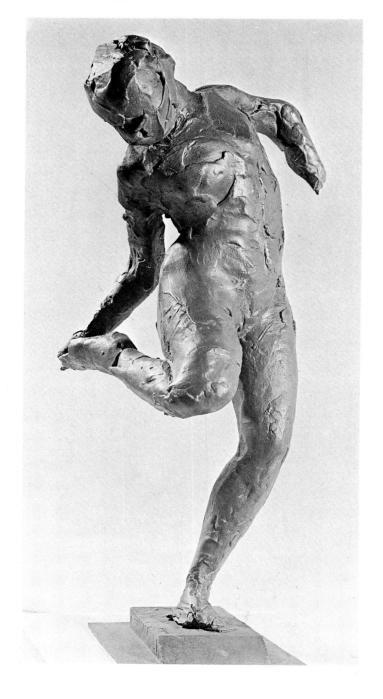

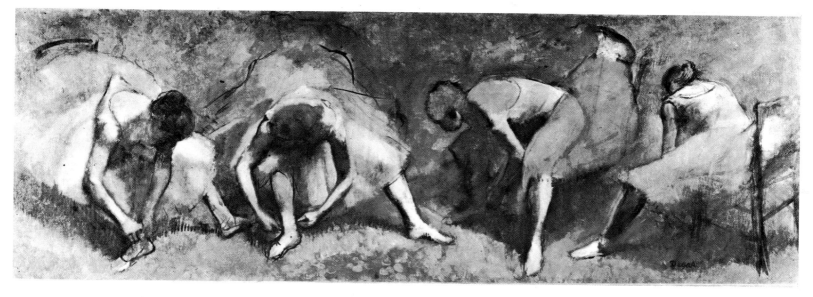

1893-98 Four Dancers Adjusting their Slippers.
Canvas, 27½ × 78¾ in. Cleveland, The Cleveland
Museum of Art, Gift of Hanna Fund. (Photo Giraudon)

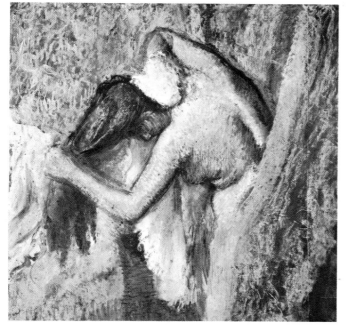

1903 Woman Drying Herself. Pastel, 29½ × 28½ in.
Chicago, Courtesy of The Art Institute of Chicago.

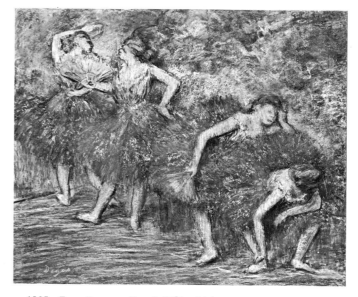

c. 1905 Four Dancers. Pastel, 25⅝ × 30 in.
Private collection.

Expertise

1

It is impossible to speak of the technical side of Degas' work without referring to Denis Rouart's authoritative study *Degas à la recherche de sa technique* (Paris, Floury, 1945, p. 56). Here is a passage dealing with the monotypes, one of the techniques most frequently used by the artist:

The Monotypes

Degas disliked the term "monotype," but it has now come into general use to designate a curious technique, somewhere between painting, pastels and engraving, which he devised and practiced a good deal. ...
He himself has described how he happened to arrive at the monotype process. He was standing by at the copperplate printer's one day when some of his etchings were being pull-

82

2

on paper in the normal way. As a rule, only a single impression could be obtained, all the ink being transferred at once to the paper. But traces of ink might remain on the plate, and then Degas would pull a second impression and sometimes even a third. These latter impressions were naturally much fainter than the first, and Degas put them away in a cardboard box, perhaps with the idea of working them up later, and in many cases he did so.

On this faint, grayish impression he applied touches of pastel. Sometimes he went no further than that, simply heightening the monotype with color. But sometimes, too, he worked over it very thoroughly and elaborately, producing a pastel for which the monotype had served merely as a starting point. His initial series of monotypes, made by inking the plate completely, in fact illustrates all these successive stages, ranging from unhighlighted impressions left in black (*The Fireplace, Reclining Woman, Woman in a Bathtub, The Toilette*, and a frieze of *Dancers*), to others slightly enhanced with coloristic touches (*Head of a Café-Concert Singer*), and finally to some veritable pastels executed on a monotype base (*Le Pas battu, Dancer on Stage*, and *Women in a Café in the Evening*). Later, instead of inking the plate completely to begin with and getting lights and halftones by wiping the ink away with a brush or rag, he took a clean plate and drew his subject on it with a brush dipped in ink thinned with turpentine. This method could not yield the deep blacks that are so striking in the previous series, but it did result in a more precise design with sharper outlines. He used this latter method for his brothel scenes and his illustrations for *Les Petites Cardinal* by Ludovic Halévy (a book of stories about the two Cardinal girls, Pauline and Virginie, who were ballet dancers at the Opera). Among the monotypes executed in this manner, we again find impressions in black ink (*Waiting for a Customer* and *The Serious Customer*) and others slightly heightened with pastel, such as *La Fête de la Patronne* ("The Madam's Birthday"). Some of the monotypes in the *Petites Cardinal* series were elaborately worked over in pastel, such as the one showing Ludovic Halévy talking with Madame Cardinal.

Finally, Degas also used a third method. With this, instead of inking or drawing only in black, he used several colors, either colored inks or more probably oil colors. The impressions thus obtained were extensively worked over with pastel, until they almost became pictures in their own right. This was the method he used for all the landscapes based on the trip he made to Burgundy in a gig with Bartholomé in 1890, which he exhibited in 1893 at the Galerie Durand-Ruel in Rue Laffitte.

ed. As he watched the printer ink the plate and then wipe it, so that the ink would only remain in the etched lines, it occurred to him to take a clean, unetched, unvarnished copperplate, to smear it with ink and then, instead of wiping it with a rag as the printer had done, to work in this uniform coat of ink with a stiff brush. Here and there he brushed the ink away or attenuated it, creating textures and halftones, removing it entirely in some places to get the strongest lights and leaving it intact in others to get those heavy shadows and night-black backgrounds which are so strikingly effective. The plate was then run through the etching press and printed

Degas as a collector

Degas' complex personality is reflected in his choice of the pictures he gathered around him. These included works by old masters, but probably much fewer than he would have liked; others by masters who had immediately preceded him in the first half of the nineteenth century; and finally works by contemporaries often very different from each other. When his collection was sold in March 1918, the catalogue included 247 items, comprising 93 paintings and 154 pastels, drawings, and watercolors and ranging from Cuyp and El Greco to Van Gogh and Cézanne — not to mention thousands of lithographs by Manet, Daumier, Gavarni, and others, as well as many Japanese prints.

As a young man he had begun buying pictures and prints, but when he undertook to help his brother out of financial difficulties he had been obliged to give up collecting. As soon as he could, from the 1890's on, he recommenced his purchases at the Hôtel Drouot auction rooms and at the Ambroise Vollard gallery. Sometimes, too, he bought directly from the artist—drawings, for example, from Suzanne Valadon. "Come and see me with some drawings," he wrote to her; "I love to see those thick, supple strokes of yours." Apart from the artists already mentioned, the walls of his apartment were hung with works by Ingres and Delacroix, whom he passionately admired, for they satisfied both the draftsman and the colorist in him; others were by Corot, Manet, Pissarro, Sisley, Renoir, Berthe Morisot, and Mary Cassatt. Among pictures by Gauguin — "A fellow who is starving and whom I profoundly esteem as an artist" — he owned *La Belle Angèle*. "It was really wonderful to see so great an artist at the end of his career conceive such a passion for the work of

1, 2 Cover and title page of "Catalogue of Old and Modern Pictures" belonging to the Degas Collection, sold at Galerie Georges Petit in Paris, on March 26-27, 1918.

3 El Greco: St. Ildefonso Writing at the Virgin's Dictation, c. 1605-10. Canvas, $44^{1}/_{4} \times 25^{3}/_{4}$ in. Washington, The National Gallery of Art, Andrew Mellon Collection. (Cat. no. 2)

4 El Greco: St. Dominic Kneeling in Prayer, c. 1605-10. Canvas, $41^{1}/_{2} \times 32^{1}/_{2}$ in. Boston, Courtesy of The Museum of Fine Arts, Maria Antoinette Evans Fund. (Cat. no. 3)

5

6

8

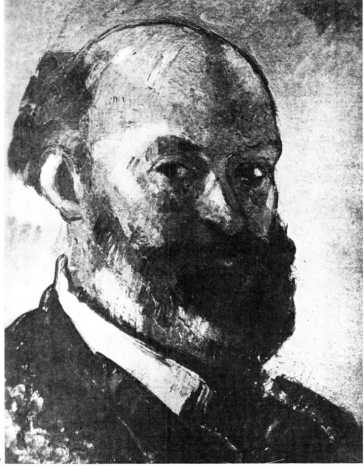

7

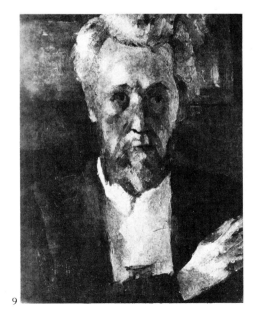

9

5 Paul Cézanne: Venus and
 Cupid, c. 1870-73. Canvas,
 $8^{1}/4 \times 8^{1}/4$ in. (Cat. no. 9)

6 Paul Cézanne: Apples, c.
 1873-77. Canvas,
 $7^{1}/8 \times 10^{1}/4$ in. (Cat. no. 10)

7 Paul Cézanne: Self-Portrait,
 c. 1879-82. Canvas,
 $13 \times 9^{1}/2$ in. Winterthur,
 Collection of Oskar
 Reinhart am Römerholz.
 (Cat. no. 11)

8 Paul Cézanne: Apples and
 Glass, c. 1879-82. Canvas,
 $8^{1}/4 \times 15^{3}/4$ in.
 (Cat. no. 14)

9 Paul Cézanne: Portrait of
 Victor Chocquet, c.
 1879-82. Canvas,
 $13^{3}/4 \times 10^{1}/2$ in.
 (Cat. no. 15)

others," wrote Ernest Rouart. "He would often repeat a saying of Ingres: 'He who lives only with thoughts of himself is a wretched man'." Daniel Halévy, too, remembered Degas' generous enthusiasms during a visit to his studio: "While talking, Degas got dressed, and as he dressed he kept walking about and taking down from the wall or picking up from the floor a canvas or a panel which he would then show me. 'Here is my new Van Gogh, and my Cézanne. I go on buying and buying! I can't stop. The trouble is that people are beginning to realize it and so they bid against me. They know that when I want something I absolutely must have it. So they play their tricks and lure me on'."

Ingres, Delacroix, and also, among his own contemporaries, Manet exerted a strong influence on Degas' work. Daumier also, very probably, guided him in the choice of certain characteristic subjects. But in collecting their works and others he was impelled solely by a disinterested admiration for their achievement. One need only think of Cézanne, Gauguin, and Van Gogh: What is there in common between their art and his? Degas was also one of the few artists who at the same time was a true collector, eager to seek out and possess whatever appealed to him. He thought of bequeathing his collection to a museum; but in the end he failed to make the necessary arrangements. Hence, after his death it was sold and dispersed.

10 Camille Corot: The Bridge
 of Limay and Château des
 Célestins, c. 1855-60.
 Canvas, 9^{1}/2 × 13^{3}/4 in.
 (Cat. no. 16)

11 Camille Corot: Chestnut
 Trees in a Rocky
 Landscape (Morvan or
 Auvergne), c. 1830-35.
 Canvas, 21^{5}/8 × 33 in. (Cat.
 no. 18)

12

14

13

14 Paul Gauguin: Moon and Earth ("Hina Tefatu"), 1893. Oil on burlap, 45 × 24¹/₂ in. New York, The Museum of Modern Art, Lillie P. Bliss Fund. (Cat. no. 40)

15 Paul Gauguin: La Belle Angèle, 1889. Canvas, 36¹/₄ × 28³/₈ in. Paris, Musée du Louvre.

15

12 Eugène Delacroix: Henry IV Giving the Regency to Marie de Médicis, copy after Rubens. Canvas, 35 × 45¹/₄ in. (Cat. no. 25)

13 Eugène Delacroix: The Battle of Nancy, sketch, 1828. Canvas, 19¹/₄ × 27¹/₂ in. (Cat. no. 26)

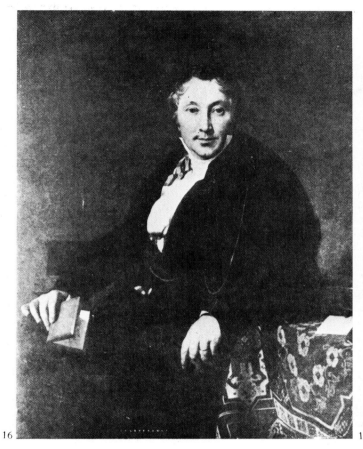

16

17

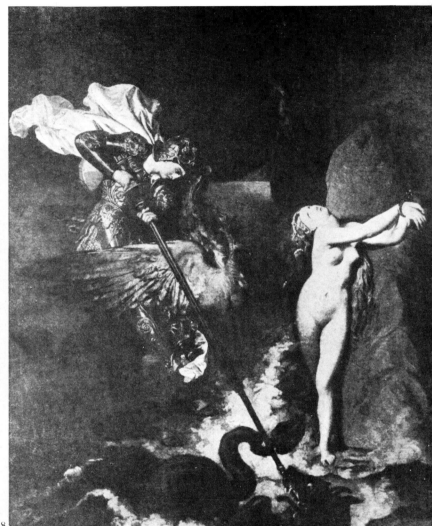

18

16 Jean-Dominique Ingres: Portrait of Monsieur Leblanc, c. 1823. Canvas, 46$^7/8$ × 36$^5/8$ in. New York, The Metropolitan Museum of Art, Purchased 1918, Wolfe Fund. (Cat. no. 54)

17 Jean-Dominique Ingres: Portrait of Madame Leblanc, 1823. Canvas, 46$^7/8$ × 36$^5/8$ in. New York, The Metropolitan Museum of Art, Purchased 1918, Wolfe Fund. (Cat. no. 55)

18 Jean-Dominique Ingres: Roger Rescuing Angelic, c. 1841. Canvas, 18$^3/4$ × 15$^1/2$ in. London, National Gallery, Reproduced by courtesy of the Trustees. (Cat. no. 56)

19 Edouard Manet: The Folkestone Boat, 1869. Canvas, 24$^3/4$ × 39$^3/4$ in. Winterthur, Collection of Oskar Reinhart am Römerholz. (Cat. no. 72)

20 Edouard Manet: Execution of Emperor Maximilian, sketch, 1867. Three fragments on canvas, 81$^1/2$ × 118$^1/4$ in. London, National Gallery, Reproduced by courtesy of the Trustees. (Cat. no. 74)

21 Edouard Manet: The Ham, 1880. Canvas, 12$^1/2$ × 16$^1/2$ in. Paris, Musée du Louvre. (Cat. no. 75)

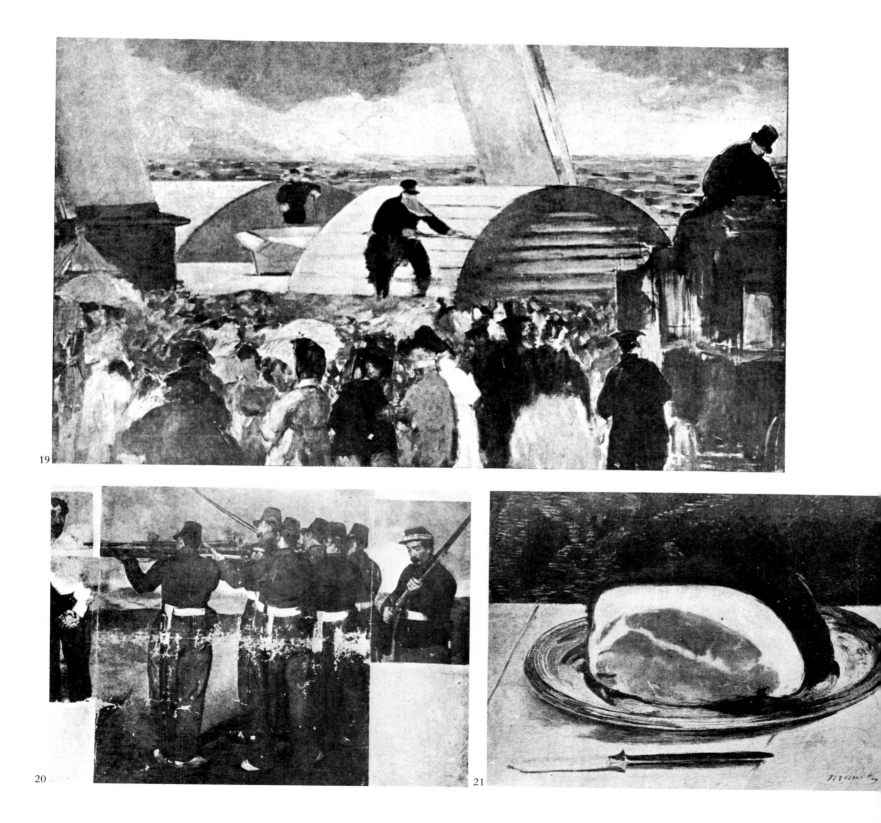

19

20 21

22

24

23

22 Berthe Morisot: Woman and Child on a Terrace at the Seaside, 1874. Canvas, 20 × 24 in. (Cat. no. 83)

23 Camille Pissarro: Landscape, 1872. Canvas, $18^{1}/8 × 21^{5}/8$ in. Oxford, Ashmolean Museum. (Cat. no. 85)

24 Camille Pissarro: Plowed Fields near Osny, 1873. Canvas, $18^{1}/8 × 21^{5}/8$ in. (Cat. no. 86)

25 Alfred Sisley: The Flood, 1873. Canvas, $19^{5}/8 × 25^{5}/8$ in. Copenhagen, Ordrupgaard Museum. (Cat. no. 90)

26 Vincent van Gogh: Sunflowers, 1887. Canvas, $19^{5}/8 × 24$ in. Bern, Kunstmuseum, Gift of Prof. Hans R. Hahnloser. (Cat. no. 93)

27 Vincent van Gogh: Apples, Pears, Lemon, and Grapes, 1887. Canvas, $18 × 21^{1}/2$ in. Chicago, Courtesy of the Art Institute of Chicago. (Cat. no. 92)

25

26

27

91

28

28 Honoré Daumier: The Connois-
seurs. Sepia, 4¹/₄ × 5¹/₈ in. Pro-
vidence, Museum of Art, Rhode
Island School of Design. (Cat.
no. 107)

29 Honoré Daumier: The Law
Court. Wash, 8¹/₂ × 13³/₈ in.
Copenhagen, Ny Carlsberg

Glyptotek. (Cat. no. 108)

30 Jean-Louis Forain: In the Loge.
Pencil, 15 × 19 in. (Cat. no. 169)

31 Jean-Louis Forain: State Secrets.
India ink, 13³/₄ × 10¹/₄ in.
(Cat. no. 170)

29

30

31

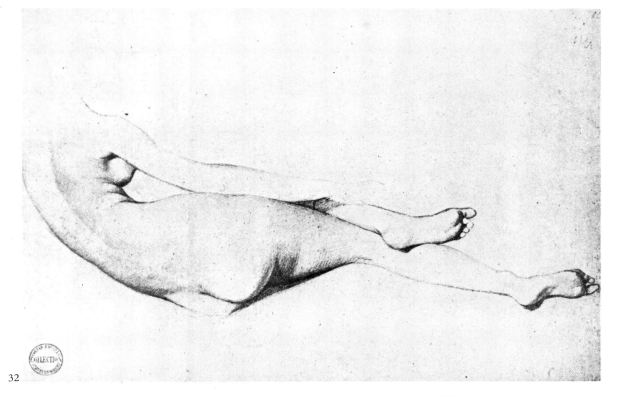

32　Jean-Dominique Ingres:
　　Study for "The Large
　　Odalisque." Pencil,
　　6³/₄ × 8 in.
　　Paris, Musée du Lou-
　　vre, Cabinet des Des-
32　　sins. (Cat. no. 204)

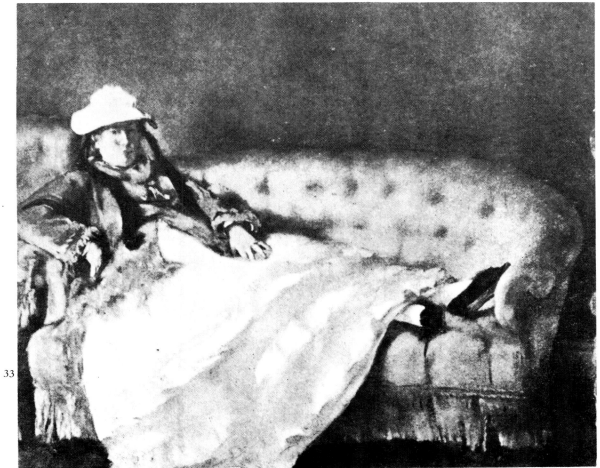

33　Edouard Manet: Por-
　　trait of Madame Ma-
　　net. Pastel, 19¹/₄ × 23⁵/₈
　　in.
　　Paris, Musée du Lou-
33　　vre. (Cat. no. 221)

Books about Degas

The basic work for any study of Degas is the catalogue by P. A. Lemoisne, *Degas et son oeuvre*, 4 vols., Paris, 1946-1949. The *oeuvre* catalogue (of paintings and pastels only) is preceded by a careful biography.

For the sculpture, see the book by John Rewald, *Degas, Works in Sculpture: A Complete Catalogue*, New York, 1944 and 1956; and the exhibition catalogue *The Complete Collection of Sculptures by Edgar Degas*, Marlborough Galleries, London, 1951.

For a comprehensive study of the monotypes, see Eugenia Parry Janis, *Degas Monotypes: Essay, Catalogue and Checklist*, Harvard University, Cambridge, Mass., 1968. Prepared as a catalogue for the exhibition held at the Fogg Art Museum in April-June 1968, this book illustrates over 300 monotypes by Degas.

Many of the artist's friends published accounts of him; in particular, Edmond Duranty, *La nouvelle peinture*, Paris, 1876; George Moore, *Confession of a Young Man*, London, 1888, *Impressions and Opinions*, London-New York, 1891, and *Modern Painting*, London-New York, 1893; Daniel Halévy, *Pays parisiens*, Paris, 1932, and *Degas parle*, Paris-Geneva, 1960 (*My Friend Degas*, transl. and ed. with notes by Mina Curtiss, Wesleyan University Press, Middletown, Conn., 1964); Georges Jeanniot, "Souvenirs sur Degas," in *La Revue Universelle*, Paris, 15 October-1 November 1933; Ernest Rouart, "Degas", in *Le Point*, Paris, February 1937.

Degas as man, artist, wit, and talker is vividly portrayed by Jacques-Émile Blanche, *Essais et portraits*, Paris, 1912 (transl. *Portraits of a Lifetime*, London, 1937), and *Propos de peintre, de David à Degas*, Paris, 1919; and by Paul Valéry, *Degas, dance, dessin*, Paris, 1936.

The purely technical side of his work has been studied with scholarly care and thoroughness by Denis Rouart, *Degas à la recherche de sa technique*, Paris, 1945.

Several painters of his own or the next generation have written or spoken about Degas in the most interesting terms: Pissarro in *Camille Pissarro, Letters to His Son Lucien*, ed. by John Rewald with the assistance of Lucien Pissarro, New York, 1943 (original French text published in *Camille Pissarro, Lettres à son fils Lucien*, Paris, 1950); Renoir in *Renoir* by Jean Renoir, Paris, 1962 (*Renoir, My Father*, Boston, 1962); Berthe Morisot in *Correspondance de Berthe Morisot*, ed. by Denis Rouart, Paris, 1950; Odilon Redon in his book *A soi-même*, Paris, 1922; Maurice Denis in his *Journal*, 3 vols., Paris, 1957-1959, and *Théories*, Paris, 1910.

Several early critics saw and described the essential characteristics of his art: J. K. Huysmans, *L'Art moderne*, Paris, 1883; Félix Fénéon, *La huitième Exposition des Impressionistes*, Paris, 1886; Gustave Geffroy, *La vie artistique*, Paris, 1894. Among the best biographies are those of Paul Lafond, *Degas*, 2 vols., Paris, 1918-1919; J. B. Manson, *The Life and Work of Edgar Degas*, London, 1927; François Fosca, *Degas*, Geneva-London-New York, 1954; and Pierre Cabanne, *Degas*, Paris, 1960. For further accounts of Degas and the many studies of style, the reader is referred to the detailed bibliography given by John Rewald in *History of Impressionism*, rev. ed., New York, 1961.

The letters, which throw revealing light on the character of the man, have been collected and annotated by Marcel Guérin, *Lettres de Degas*, Paris, 1931. An English edition of the letters, translated by Marguerite Kay, was published in London in 1947.